Marking our times

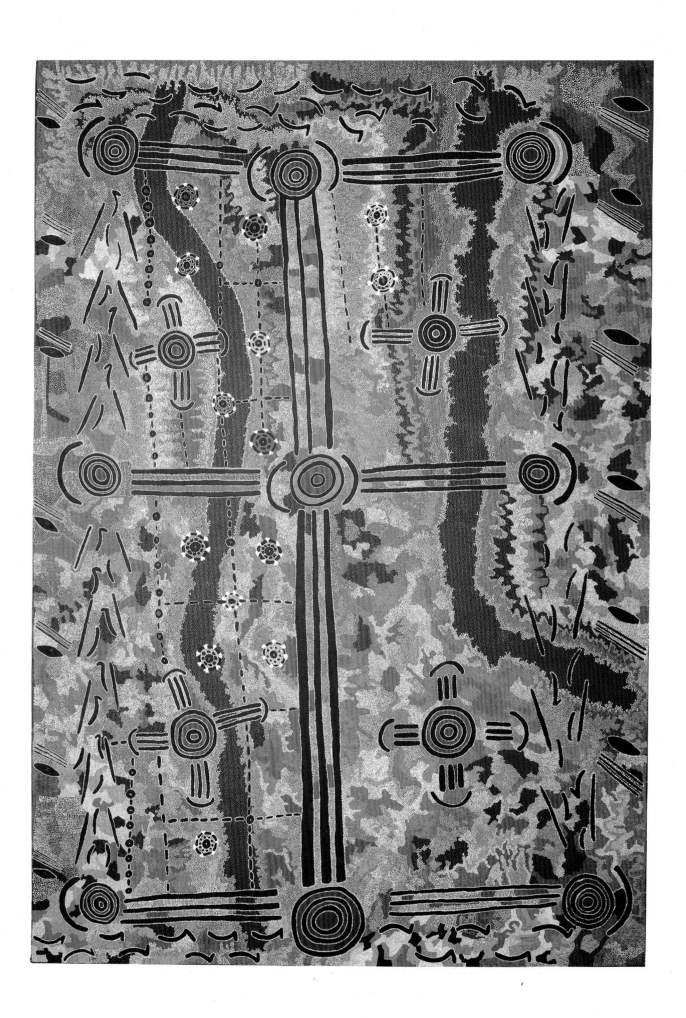

Marking our times

Selected works of art from the
Aboriginal and Torres Strait Islander Collection
at the National Gallery of Australia

Avril Quaill

National Gallery of Australia

Warning: Indigenous Australians should be aware that this book contains the names of deceased people and images of their artwork. In indigenous communities restrictions apply on the use of names or the works of art by people who have passed away. The works in this publication have been cleared by the appropriate communities.

Text and photography by the National Gallery of Australia
© National Gallery of Australia, Canberra, ACT 2600, 1996

Cataloguing-in-publication data

National Gallery of Australia.
Marking our times: selected works of art from the Aboriginal and Torres Strait Islander collection at the National Gallery of Australia.

ISBN 0 642 13038 8
1. National Gallery of Australia - Catalogs. 2. Aborigines, Australian - Catalogs. 3. Torres Strait Islanders - Art - Catalogs.
4. Art, Australian - Catalogs. 5. Art - Australian Capital Territory - Canberra - Catalogs. I. Quaill, Avril. II. Title.

709.940749471

Edited, designed, typeset and produced by the Publications Department of the National Gallery of Australia
Designed by Kirsty Morrison
Edited by Maggie Saldais and Karen Leary
Colour separations by Prepress Services, Perth
Printed in Australia by Lamb Printers, WA

Distributed by:
Thames and Hudson (Australia) Pty Ltd
11 Central Boulevard, Portside Business Park, Port Melbourne, Victoria 3207, Australia

Thames and Hudson Ltd
30–34 Bloomsbury Street, London WC1B 3QP, United Kingdom

Thames and Hudson Inc
500 Fifth Avenue, New York, NY 10110, United States of America

ISBN in USA 0-500-97431-4
Library of Congress 95-61182

Cover:
Sally Morgan
Wittenoon (landscape II)
(detail, full image reproduced p. 69)

Frontispiece:
Paddy Jupurrurla Nelson
born c. 1919
Roy Jupurrurla Curtis
born 1953
Victor Jupurrurla Ross
born 1953
Frank Jakamarra Bronson
born 1948
Towzer Jakamarra Walker
born 1925
Maggie Napurrurla Poulson
born c.1935
Bessie Nakamarra Sims
born 1932
Jillie Nakamarra Spencer
born 1943
Ruby Nakamarra Collins
born 1947
Pansy Nakamarra Stewart
born 1946
Paddy Japaljarri Sims
born 1917
Paddy Japaljarri Stewart
born c.1940
Warlpiri

Yarla manu Ngarlajiyi Jukurrpa
(Bush Potato and Bush Carrot Dreaming)
1992
synthetic polymer paint on canvas
300.0 x 400.0 cm
Yuendumu, Northern Territory

An ancestral fight escalates into an epic battle between Ngarlajiyi (Bush Carrot) people from Waputarli (Mount Singleton), and Yarla (Bush Potato) people. Social structure and kinship connections are reflected in this collaborative work.

Preface

Marking our times provides a visual feast of contemporary Aboriginal art. The brief commentaries accompanying the works illustrated are intended to suggest the general context of the works, but not to relate their full complexities, which would be an impossible task in a volume of this size.

All works of art featured in this book are in the collection of Aboriginal and Torres Strait Islander art at the National Gallery of Australia, Canberra. They have all been acquired since the publication in 1987 of *Australian Aboriginal Art: A Souvenir Book of Aboriginal Art in the Australian National Gallery*. Most of the works were made during the past fifteen years, with some notable exceptions, such as Lindsay Roughsey's *Rainbow Serpent* of 1966.

I would like to express my appreciation and thanks to the following people for their assistance and support in compiling this book: Wally Caruana, curator, and Sue Jenkins, assistant curator, Department of Aboriginal and Torres Strait Islander Art; Bruce Moore, Richard Pedvin, Brenton McGeachie and Willi Kemperman, Photographic Services; Gloria Morales, conservator; Greg Howard, conservation officer; and Djon Mundine, consultant in the field, Bula Bula Arts, Ramingining, Northern Territory.

In the text, the artists' names are followed by details of their language or clan and dates. Measurements of the works are given in centimetres, height before width.

Avril Quaill
Department of Aboriginal and Torres Strait Islander Art
National Gallery of Australia, Canberra, 1996

Introduction

Since the publication of the National Gallery of Australia's first book on Aboriginal art in 1987, Australia has witnessed a remarkable surge of interest in Aboriginal and Islander arts and cultural practices. The social and political gains made by Aboriginal people since the late 1960s have given rise to a high level of public awareness of indigenous art whereby it is now represented regularly in major exhibitions and hangs in public and private collections, both locally and internationally.

This book aims to give the viewer a visual document of the richness and diversity of Aboriginal and Islander art in Australia today, as reflected in the National Collection. It highlights the artistic achievement of a selection of major artists and features new developments in media and artistic idioms.

Since the establishment of the Department of Aboriginal and Torres Strait Islander Art within the National Gallery of Australia in 1984, the collection has grown to include works from the entire range of portable artistic expression which is intended for the public domain: paintings on bark, canvas and boards, sculpture and carving, prints and textiles, incised pearlshells, fibre and feather work, drawings, watercolours, photographs, ceramics and works in other media that are particular to specific regions and times. As this book shows, modern technologies such as neon light and video are also used by indigenous artists.

The National Gallery's collection of Aboriginal and Torres Strait Islander art is displayed in the Loti & Victor Smorgon Gallery at the entrance of the building. It features *The Aboriginal Memorial*, 1987–88, an installation which encourages the visitor to walk through its meandering path. The complement of works in this gallery are changed every six months for reasons of conservation and to give the regular visitor a view of the many riches of the collection. In addition, special thematic and focus exhibitions are held in other rooms of the National Gallery and Aboriginal and Islander art is now a constant inclusion in the galleries of Australian art situated on the upper level.

Over the years the collection has kept track of developments in the production of art across indigenous Australia. The majority of holdings date from the mid-1970s to the present — the first major purchase was made in 1976: a collection of 139 bark paintings by West Arnhem Land artist, Yirawala. More recent highlights include the *Krill Krill* 1984 series of paintings by Rover Thomas and Paddy Jaminji from the eastern Kimberley; paintings by George Milpurrurru and by Emily Kame Kngwarreye; Robert Campbell Jr's historic canvas *Aboriginal embassy;* and a series of articulated dance machines and headdresses by Ken Thaiday from the Torres Strait. The collection includes significant holdings of prints and posters by Aboriginal and Islander artists put together largely by the Gallery's Department of Australian Prints. The collection of art from the deserts of Australia includes several major individual works and a series of fourteen canvases by the Warlpiri artists of Yuendumu which describe the creation of the ancestral landscape along kinship lines.

Art is central to Aboriginal life; it expresses the identity of individuals and family groups, and connects people to the land. It also comments on the contemporary realities of its makers.

The evidence of rock paintings and engravings across the continent suggests that the traditions of Aboriginal art date back at least 50,000 years, well before the well-known cave paintings of Lascaux and Altamira in Europe. Most art is ephemeral, made for particular occasions and from natural materials which perish over a relatively short period of time. While various forms of portable art developed over the millennia, the surge in activity since the beginning of the twentieth century — especially in the past fifty years, where art has left communities and entered the public domain — has seen a dramatic increase in the practice of bark painting, weaving and sculpture-making as well as the introduction of new techniques and materials such as synthetic paints and canvas. In the main,

rather than replacing age-old methods, these newly introduced techniques are practised alongside more traditional forms.

The Dreaming is at the heart of Aboriginal life and it provides the great themes of Aboriginal art. The English word 'Dreaming' has come to be used by Aboriginal and non-Aboriginal people alike to describe the spiritual, natural and moral order of the universe. The Dreaming chronicles the actions of the supernatural beings and creator ancestors who, in both human and non-human form, traversed the universe and created all living things, shaped the world as it is known today and laid down the laws of social and religious behaviour. The entire continent of Australia is a matrix of Dreamings, many of which follow the ancestral paths across the land while others are specific to particular places. The Dreaming is not restricted to the past; the powers of the ancestral beings reside within the earth and are constantly drawn upon to sustain life by generation after generation of people through ceremony and art. Among the major Dreamings which inspire some of the work illustrated in this book are those concerning the Rainbow Serpent, who in various guises is ubiquitous to indigenous Australia; the Djang'kawu who gave birth to clans in Arnhem Land; and the Wandjina, who came across the sea to the Kimberley in north-western Australia.

Indigenous Australia is not homogeneous. This is reflected in the variety of artistic styles, subjects and media across the country. Each tradition of art has its own visual language and conventions. Naturalistic and non-figurative images, and geometric motifs exist to varying degrees across the art regions of the country. For example the method of crosshatching clan designs, in some areas called *rarrk*, is largely specific to Arnhem Land. In the desert, dotting techniques based on the construction of ground paintings and body paintings are now a familiar feature of the paintings on canvas from the region.

Although the pictorial symbols in the visual arts may appear small in number they can carry a multitude of meanings. Interpretation of images and designs rests very much with the awareness and knowledge of the viewer; thus a fully initiated person would be able to perceive the deeper levels of meaning of a work, while an outsider would only appreciate the more public interpretations. By making the distinction between the ritually closed meanings and the open meanings, artists can protect the integrity of their work in the public arena.

The various stylistic differences operating within indigenous Australia are reflected in this book, which in the main is organised along geographic lines: from west to east in Arnhem Land, over to Wadeye and the islands of the Tiwi people near Darwin, on to the vast desert regions of central Australia, then to the Kimberley, northern Queensland and the Torres Strait, and finally the urban and rural areas which dot the seaboard of the continent.

The flourishing interest in Aboriginal and Islander art has created new opportunities for artists. While the imperatives to produce art for traditional purposes continue, the expanded environment in which indigenous art now operates has created further reasons for artists to continue traditions to express the values of their culture to the wider world in which they live. Their work is a testament to the enduring and dynamic nature of indigenous culture.

As we move to the end of another millennium, the work of the artists presented in this volume — and the many hundreds of others working today — expresses to the world the values and aspirations of indigenous people in modern Australia. Indeed, through their work, Aboriginal and Islander artists are marking our times.

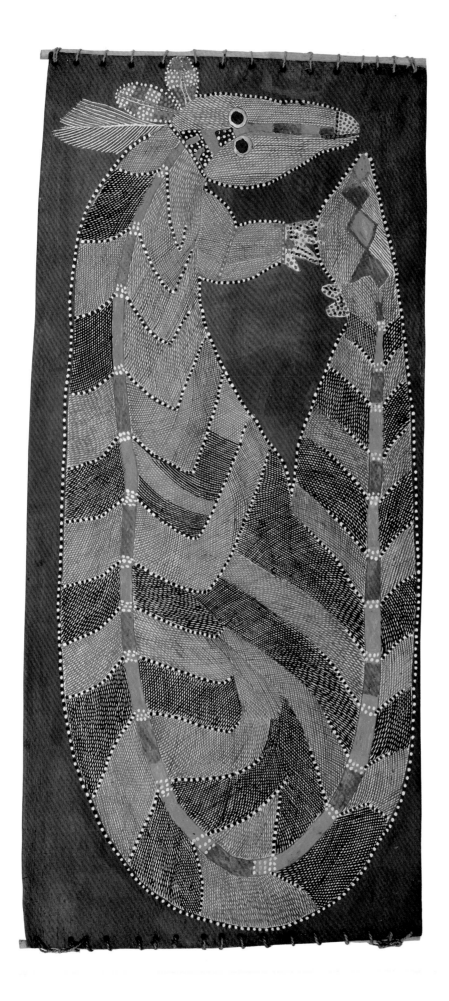

Peter Marralwanga
Kuninjku (Eastern Kunwinjku) 1916–1987
Kangaroo-headed
Rainbow Serpent
1980
natural pigments on eucalyptus bark
110.0 x 50.5 cm
Marrkolidjban, west Arnhem Land, Northern Territory

The artist depicts the Rainbow
Serpent as a snake with the tail of
a fish and the head and paw of a
kangaroo indicating the relationship
between clans associated with these
animal totems. The feathered
headdress is akin to one worn in
ceremony, used here to connect
the image to the spiritual domain.

John Mawurndjul

Kuninjku (Eastern Kunwinjku) born 1952

Rainbow Serpent at Kurdjarnngal

1991
natural pigments on eucalyptus bark
243.0 x 80.0 cm
Mumeka, west Arnhem Land, Northern Territory

This complex image of intertwining
figures represents the co-existence of
the physical and spiritual forces
present at the site of Kurdjarnngal.
The site is associated with Ngalyod,
the Rainbow Serpent, and with the
Yawkyawk, female water spirits
(one of the transformations of the
Rainbow Serpent). The artist makes
extensive use of *rarrk* (crosshatching)
in this painting.

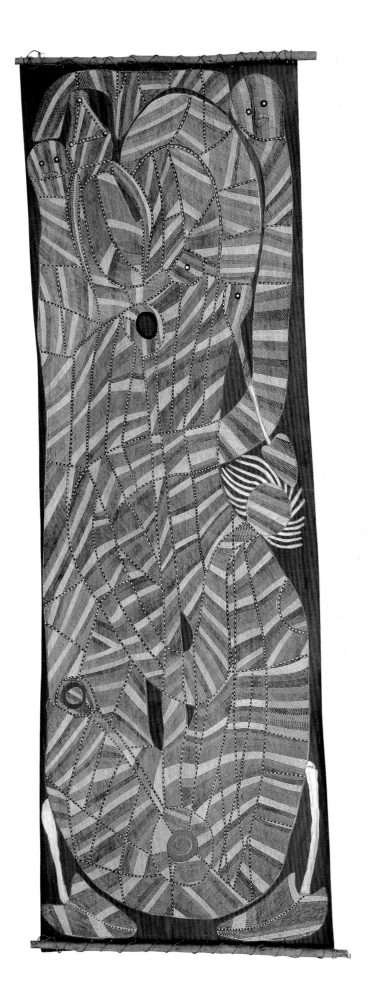

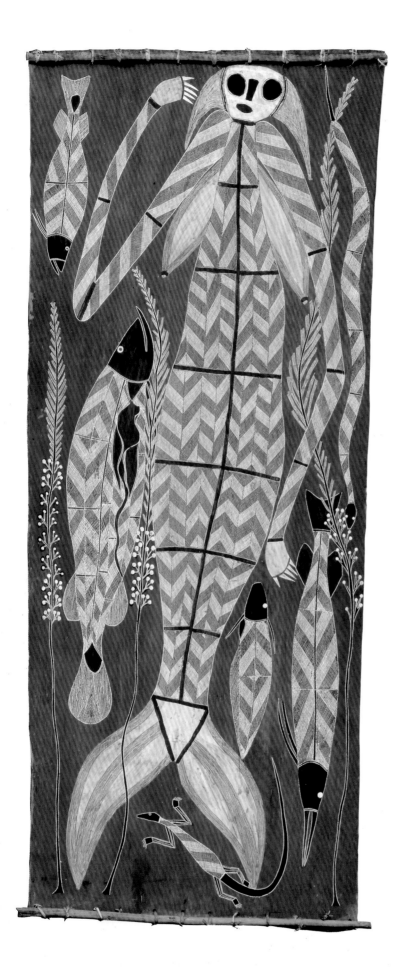

Robin Nganjmirra
Kunwinjku 1951–1991

Likanaya
1989
natural pigments on eucalyptus bark
191.0 x 81.0 cm
Gunbalanya (Oenpelli), west Arnhem Land,
Northern Territory

Likanaya, one of the daughters of
Yingarna, the Rainbow Serpent,
escapes the advances of a giant called
Luma Luma by jumping into a
waterhole and growing a fish-tail.
Robin Nganjmirra uses the patterns
of *rarrk* (crosshatching) to suggest
the figures seen swimming in water.

Mick Kubarkku

Kuninjku (Eastern Kunwinjku) born *c*.1925

Yawkyawk, freshwater mermaid

1992
natural pigments on wood
136.0 x 11.0 x 11.0 cm
Kubumi, west Arnhem Land, Northern Territory

Yawkyawk, also known as
Ngalkunburriyaymi, means a young
woman with the tail of a fish.
This water spirit appears in many
different forms and is one of the
transformations of the
Rainbow Serpent.

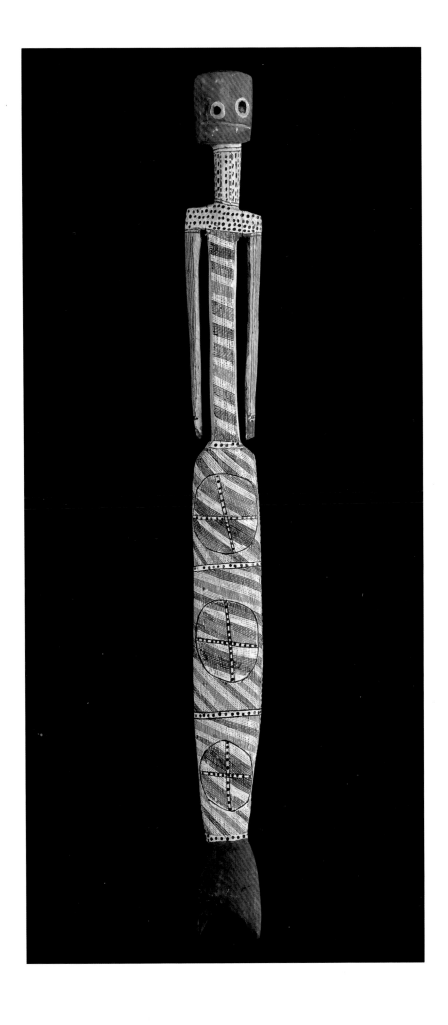

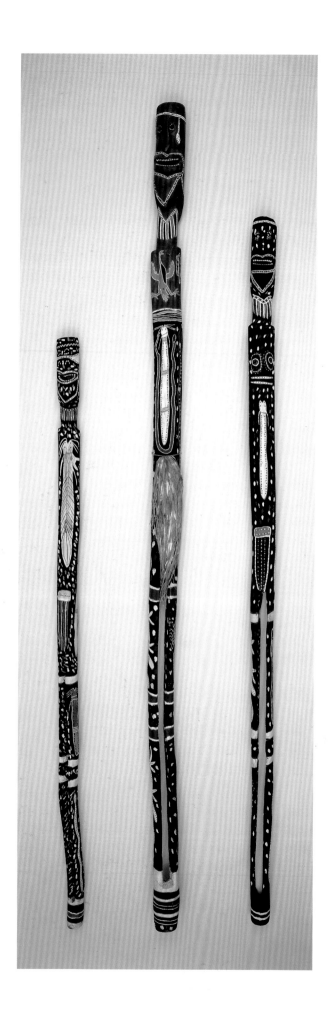

Paddy Fordham Wainburranga

Rembarrnga born 1941

Gammarrang and his family

1991

natural pigments on wood, fibre

heights 280.0 cm (Gammarrang),

330.0 cm (Narditjan), 300.0 cm (Balang)

Jarruluk, central Arnhem Land, Northern Territory

These three sculptures represent
Gammarrang (left), his mother
Narditjan (centre), and his sister,
Balang (right). As a child,
Gammarrang was taken from his
mother and sister by balangjalngalan
spirits. Gammarrang later grew to
be a very wise and respected person
in the clan.

Paddy Lilipiyana
Liyagalawumirri c.1914–1993

David Malangi
Manyarrngu-Djinang born 1927

George Milpurrurru
Ganalbingu born 1934

Jimmy Wululu
Daygurrgurr Gupapuyngu born 1936

Paddy Fordham Wainburranga
Rembarrnga born 1941

and other Ramingining artists.

The Aboriginal Memorial
1987–88
natural pigments on wood
heights from 40.0 cm to 327.0 cm
Ramingining, central Arnhem Land,
Northern Territory
Purchased with the assistance of funds from
National Gallery admission charges

This monumental installation was
created during 1987 and 1988,
Australia's bicentenary year.
It is dedicated by its makers to all
indigenous Australians who defended
their land and perished in the 200
years of white settlement. Though
a memorial, its imagery speaks of life,
continuity and a new beginning.
It is displayed in the first room of the
National Gallery.

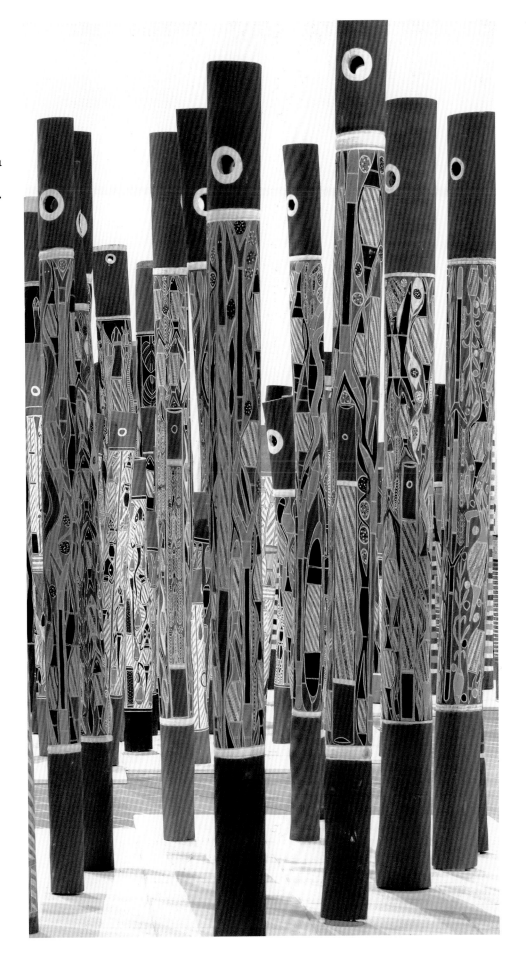

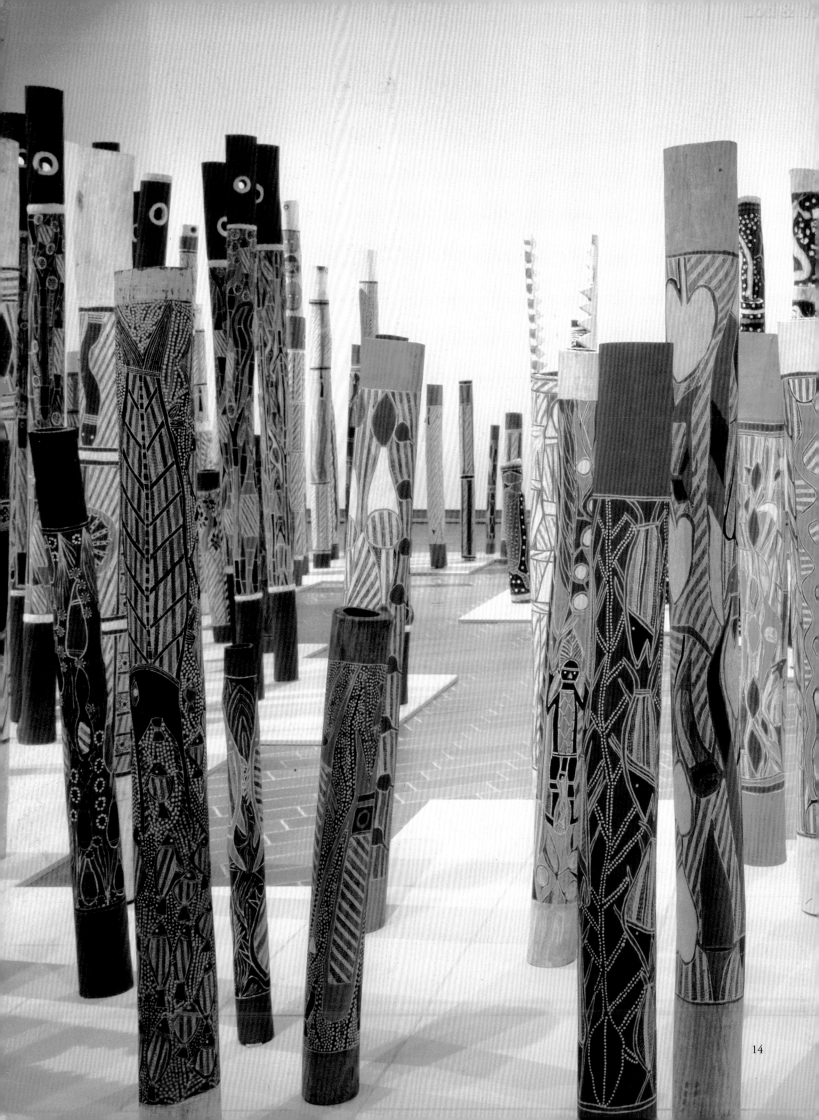

14

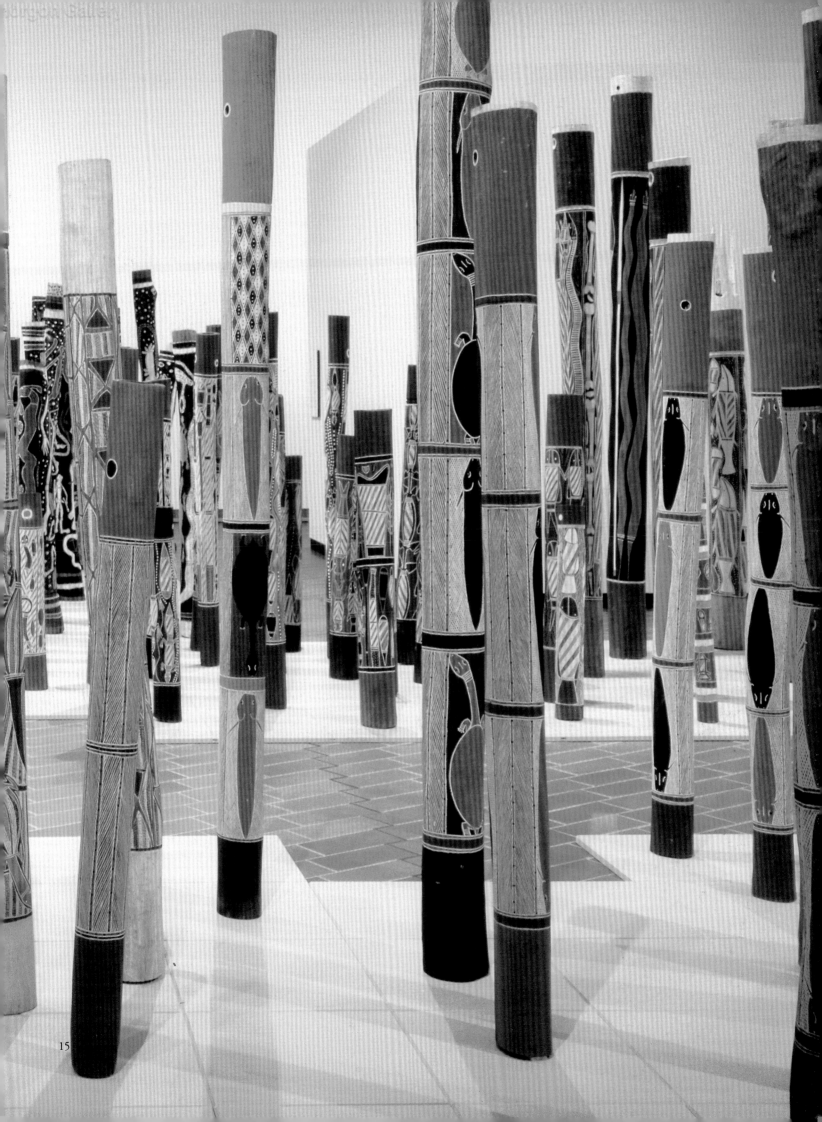

15

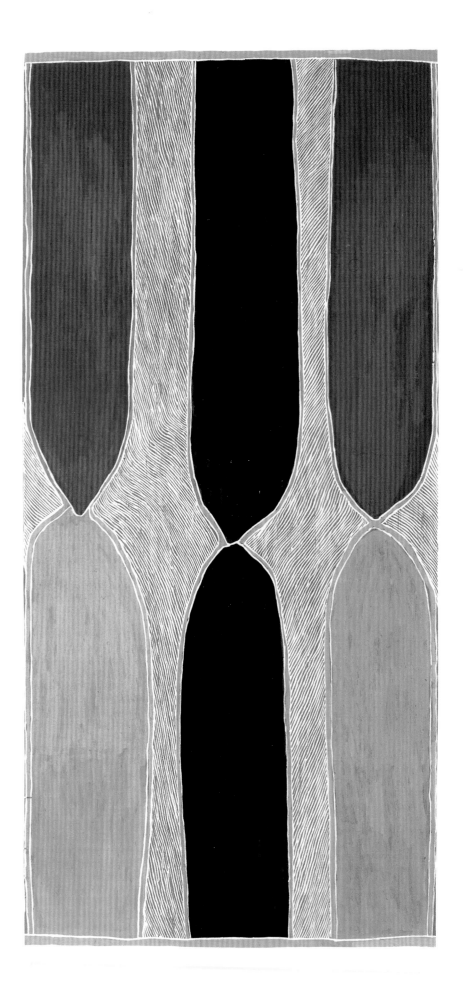

Namiyal Bopirri
Liyagalawumirri born 1927
Sacred rocks — Gurruwana story
1993
natural pigments on composition board
142.2 x 68.0 cm
Ramingining, central Arnhem Land, Northern
Territory

Gurruwana is a site belonging to
Wititj, the Olive Python, who along
with other Rainbow Serpents is
associated with the monsoonal rains
of Arnhem Land.

George Milpurrurru

Ganalbingu born 1934

Liya dhamala (mosquito house)

1990
natural pigments on eucalyptus bark
261.0 x 98.5 cm
Ramingining, central Arnhem Land, Northern Territory

This is an igloo-shaped hut which is completely closed in except for a doorway and a hole in the roof for the smoke to escape. It is enclosed like this to keep out mosquitoes in the wet season. We made these just recently but now we have mosquito nets.

George Milpurrurru

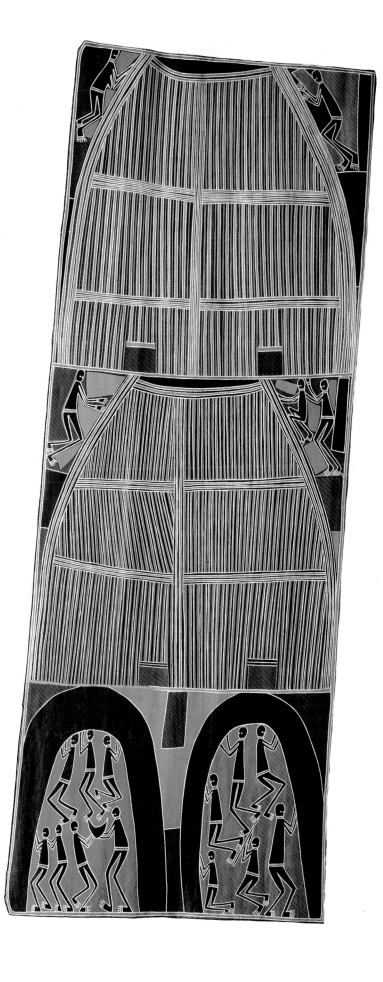

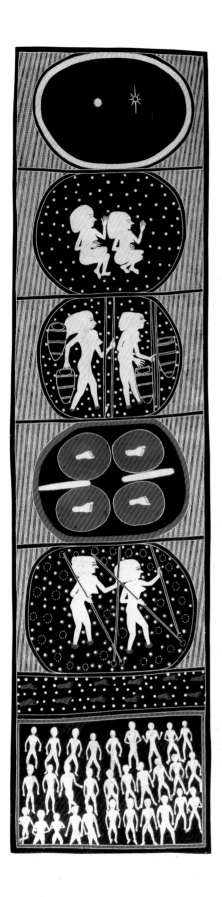

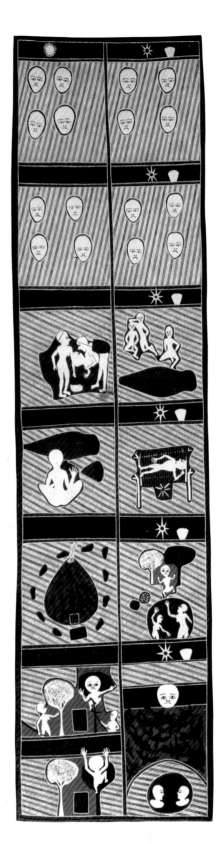

Jack Wunuwun
Murrungun-Djinang 1930–1990
In the beginning of time
1990
natural pigments on eucalyptus bark
159.1 x 41.2 cm; 159.4 x 45.0 cm
Gamardi, central Arnhem Land, Northern Territory

This striking diptych describes the genesis of the universe, created by the ancestral Sun (Djang'kawu) and the Morning Star (Banumbirr) represented as two women travelling through the cosmos. They also establish the basis of social organisation. In the final panels, the boy Ngarritj pushes the sky up to let in the light while he himself becomes the moon.

David Malangi

Manyarrngu-Djinang born 1927

Dhamala story

1993
natural pigments on eucalyptus bark
180.0 x 100.0 cm
Yathalamarra, central Arnhem Land,
Northern Territory

The two Djang'kawu Sisters came from the east; they changed their language when they got to Dhamala. They named the people and the places and became part of the tribe. This is Milmindjarrk where the waterhole is [top left].
This area is called Dhamala at the mouth of the Glyde River.

David Malangi

The black areas across the bottom of the painting represent the coastal waters at Dhamala on the northern coast of Arnhem Land; the thin black vertical column is the Glyde River.

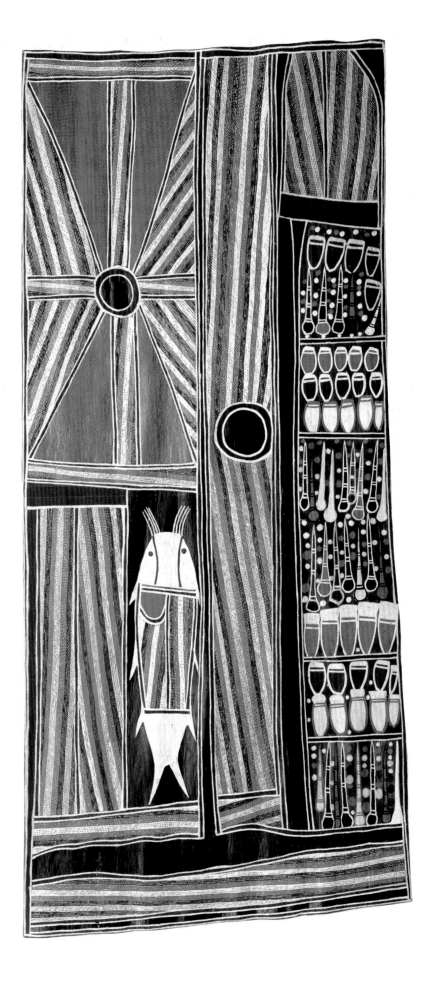

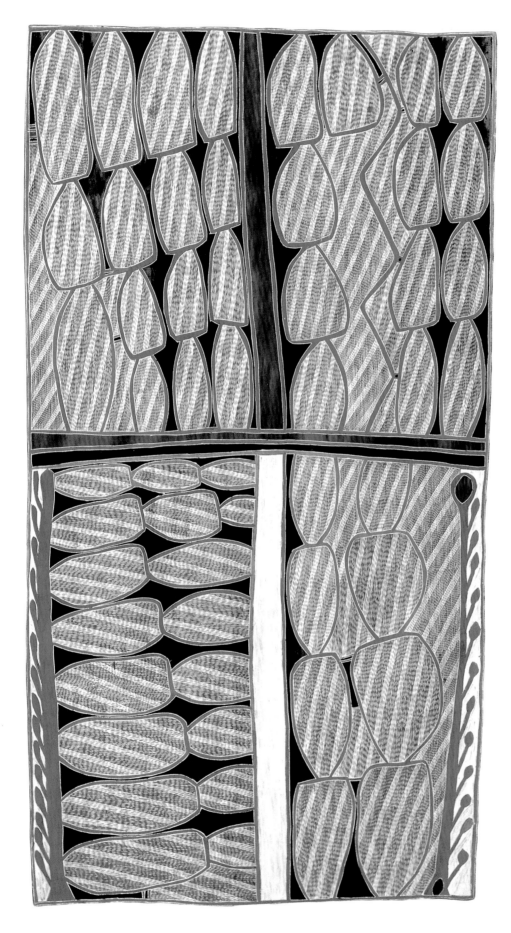

Dorothy Galaledba
Gun-nartpa born *c.*1967
Jin-gubardabiya, triangular
pandanus skirt
1989
natural pigments on eucalyptus bark
168.0 x 92.0 cm
Gochan Jiny-jirra, central Arnhem Land,
Northern Territory

The repeated motif represents the
Jin-gubardabiya, the ancestral
Triangular Skirt. The skirt is woven
from pandanus fibres and worn like
an apron. Symbolically, it is associated
with the uterus and fertility, both of
the Gun-nartpa clan women and in
nature generally.

Elsie Bulung

Balmbi born 1929
Mat
1993
woven pandanus fibres, natural dyes
240.0 cm diameter
Yathalamarra, central Arnhem Land,
Northern Territory

Innovative developments have
occurred in the art of fibre weaving
as practised by the women of
Arnhem Land. After the arrival of
Europeans in the area, a functional
flattened version of the traditional
conical mat emerged. Elsie Bulung
has created a striking pattern of
radiating lines emanating from
the central oval shape which recalls
the sacred clan waterhole.

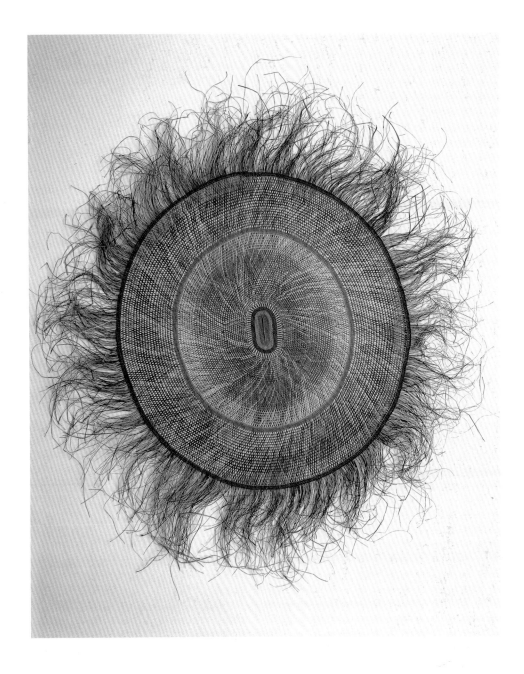

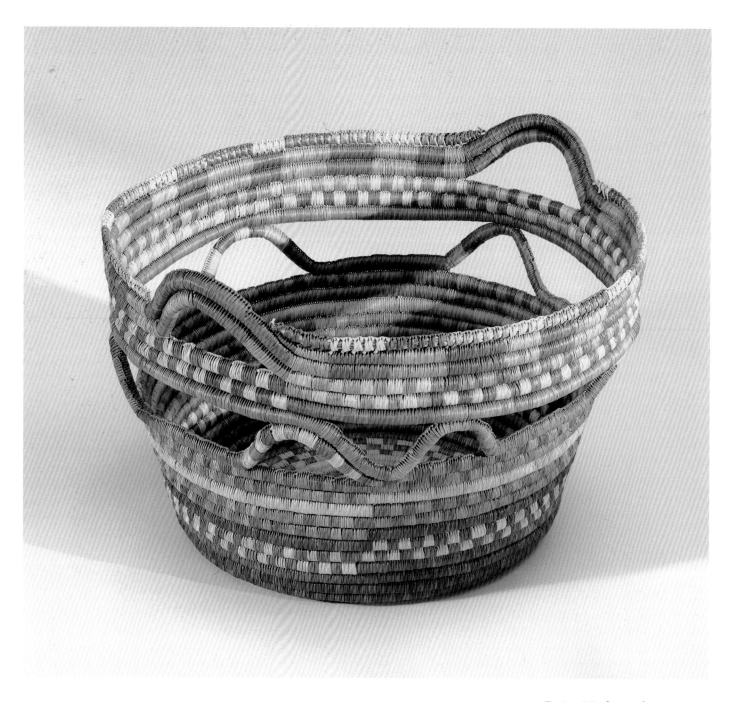

Daisy Nadjungdanga
Kunibidji born 1945
Basket
1989
fibres, natural dyes
34.1 x 54.5 x 39.6 cm
Maningrida, central Arnhem Land,
Northern Territory

The technique of coil-weaving as
practised by Aboriginal groups in
southern Australia was carried to
Arnhem Land by missionaries in the
1930s. In Arnhem Land women use
this method to weave innovative and
functional pandanus baskets.

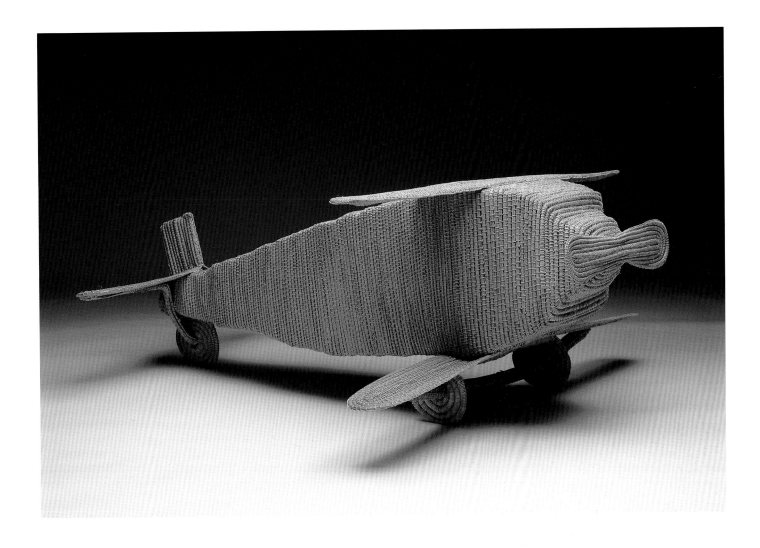

Yvonne Koolmatrie
Ngarrindjeri born 1945
Bi-plane
1994
woven sedge rushes
113.0 x 50.0 x 135.0 cm
Berri, South Australia

I started from the front and I weaved
right down to the tail. I did the wheels
and wings after ... There is no-one else
who I can ask [for technical advice]
I have to work it out for myself.
Yvonne Koolmatrie

The Ngarrindjeri people of the
Coorong region, an expanse of coastal
sand dunes at the mouth of the
Murray River in South Australia,
usually use the technique of coil
woven sedge grass to make eel traps
and baskets.

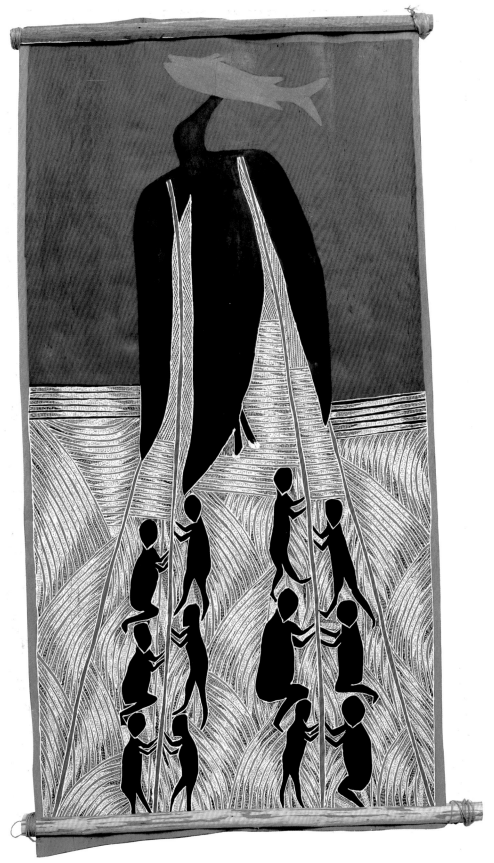

Wandjuk Marika
Rirratjingu 1927–1987
Dispersion of the clans
1986
natural pigments on eucalyptus bark
122.0 x 62.1 cm
Yirrkala, north-east Arnhem Land, Northern Territory
Purchased from
National Gallery admission charges 1987

The creative acts of the Djang'kawu are described in a major Dhuwa moiety saga concerning two sisters and their bother who came across the sea from the east. Buwata the Bustard (Australian plains turkey) accompanied the Djang'kawu, who gave birth to the coastal saltwater clans. (Dhuwa and Yirritja are names of two complementary social and religious categories in central Arnhem Land.)

Banduk Marika

Rirratjingu born 1954

Yalambara

1988
colour linocut on paper
70.0 x 42.0 cm
Sydney
Commissioned by the National Gallery of Australia,
Canberra, and the Australian Bicentennial Authority
1988

Yalambara is the site where the
Djang'kawu landed. The Morning Star
which guided the Djang'kawu to
Yalambara is depicted in the top right
of the painting. The central panel
denotes the footprints of Djanda the
Goanna across the shifting sands.

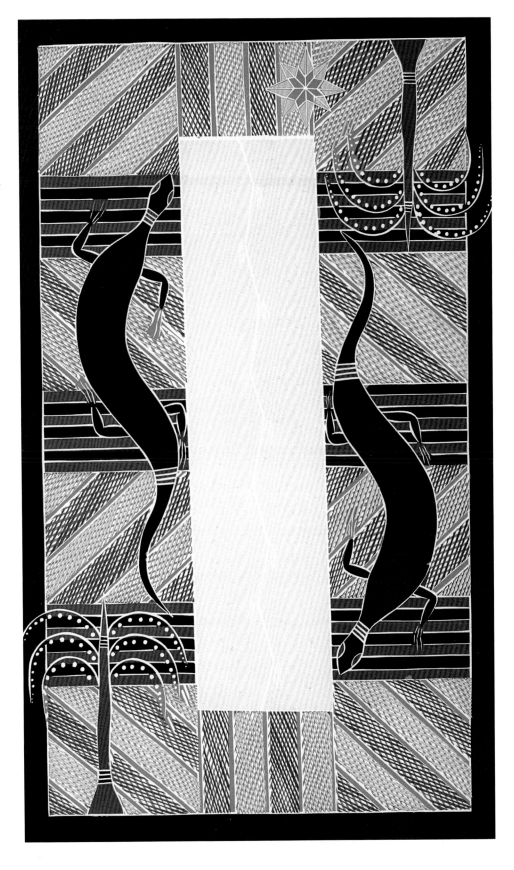

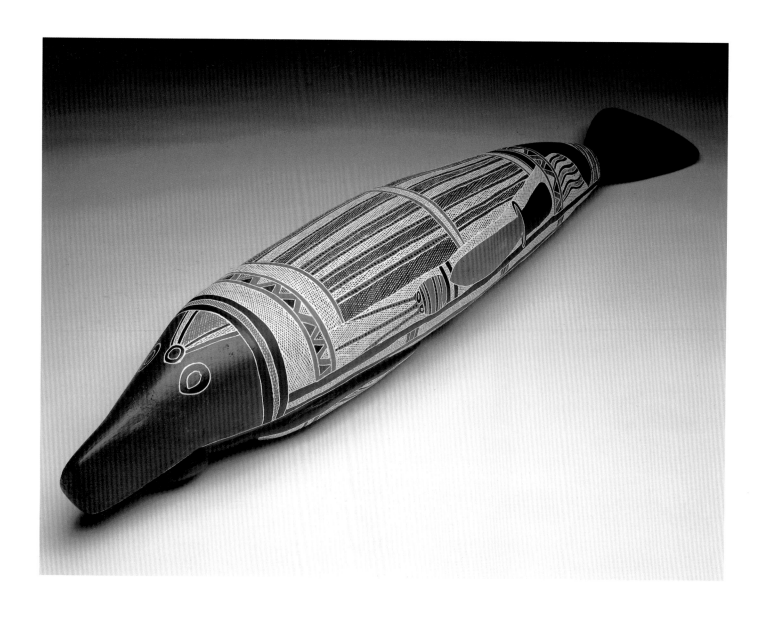

Dundiwuy Wanambi
Marrakulu born *c*.1936
Wuymirri the Whale
1990
natural pigments on wood
21.5 x 18.0 x 135.0 cm
Gurka'wuy, north-east Arnhem Land,
Northern Territory

The Whale Dreaming originates near
Galiwinku, on Elcho Island.
Dundiwuy Wanambi has given
Wuymirri's body the shape of a
dugong and covered it in Munyuku
clan designs. The lines on its back
show how, in the Dreaming, the whale
was cut up with Macassan knives.
These knives are depicted on its back.

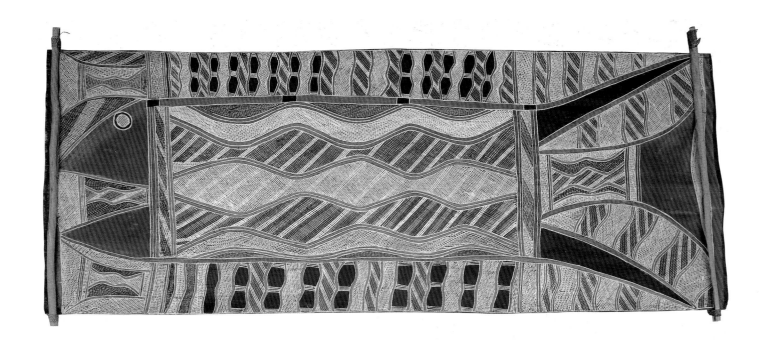

Narritjin Maymuru
Manggalili 1922–1981
Nguykal the Kingfish
1978
natural pigments on eucalyptus bark
59.0 x 160.5 cm
Yirrkala, north-east Arnhem Land, Northern Territory

Nguykal the Kingfish features in
Manggalili clan creation stories which
include those about Guwak the
Koel-Cuckoo and the creation of the
land at Djarrakpi. Guwak, on one of
his flights, saw Nguykal swimming
below him. Feeling hungry, Guwak
promised the Kingfish some land if
he would jump out of the water.
Nguykal did so, only to be devoured
by Guwak.

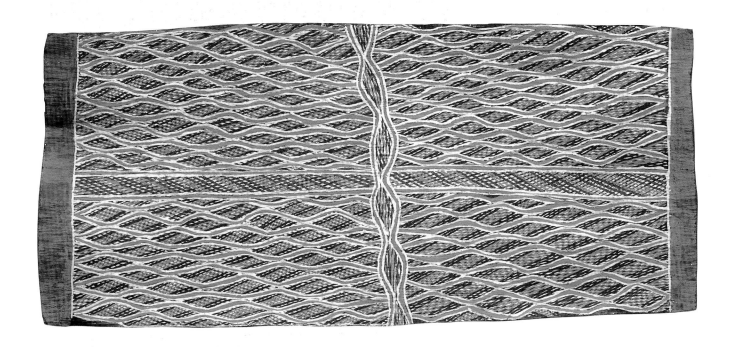

Birrikitji Gumana
Dhalwangu *c.*1898–1982
Rapids in the Koolatong River
*c.*1960
natural pigments on eucalyptus bark
29.0 x 68.0 cm
Yirrkala, north-east Arnhem Land, Northern Territory

Birrikitji uses a variation of the
Dhalwangu clan pattern of lines of
joined diamond shapes to represent
the rapids in the Koolatong River
in full flow during the wet season.
A rocky bar, depicted as the central
horizontal line in the painting,
runs across the river. The Koolatong
is the home of several Dhalwangu
clan ancestors.

Matjuwi Burarrwanga

Gumatj born *c.*1925

Digging sticks on Gumatj Fire and Honey

1994
natural pigments on eucalyptus bark
161.2 x 64.8 cm
Matamata, north-east Arnhem Land,
Northern Territory

The two pointed shapes that seem to pierce the surface of this bark painting depict digging sticks related to ceremonies of the Gumatj people at Matamata. The spiritual forces present during these ceremonies are evoked by the dazzling effect created by the patterns of the painting.

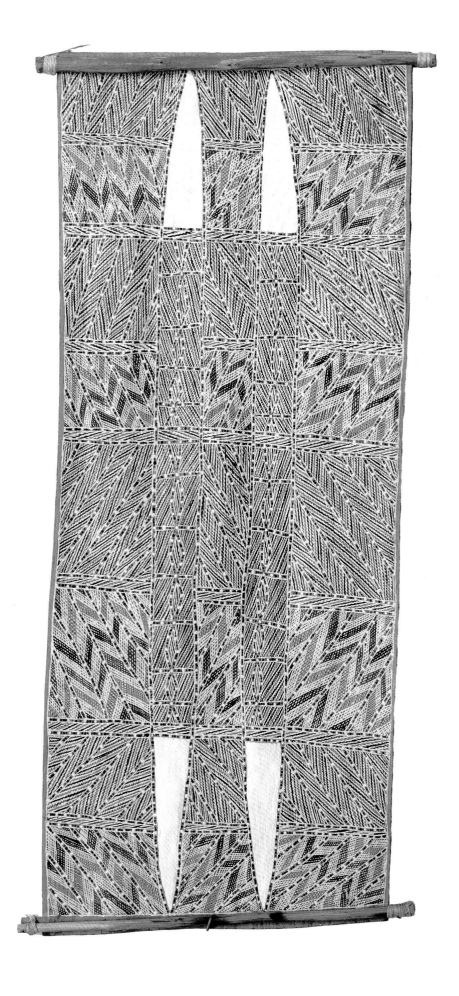

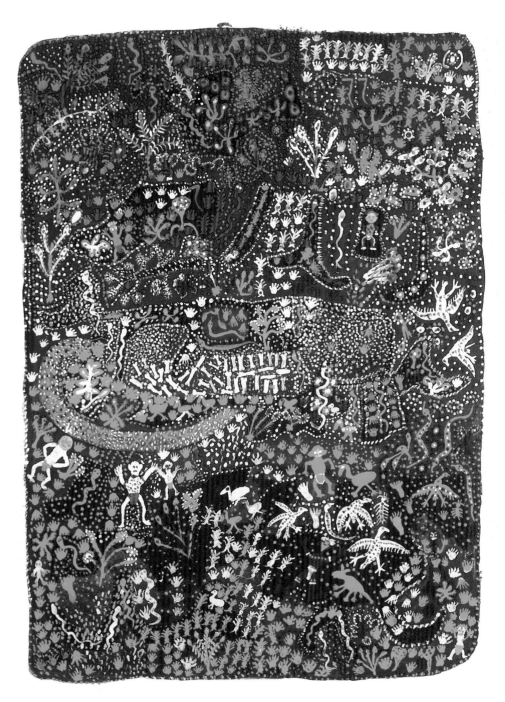

Willie Gudabi
Alawa born *c.*1917
Gabal ritual
1991
synthetic polymer paint on canvas
176.6 x 130.0 cm
Ngukurr, south-east Arnhem Land, Northern Territory

Willie Gudabi's colourful paintings portray activities surrounding circumcision and mortuary ceremonies. They can also be read as traditional maps, indicating boundaries between adjacent clans.

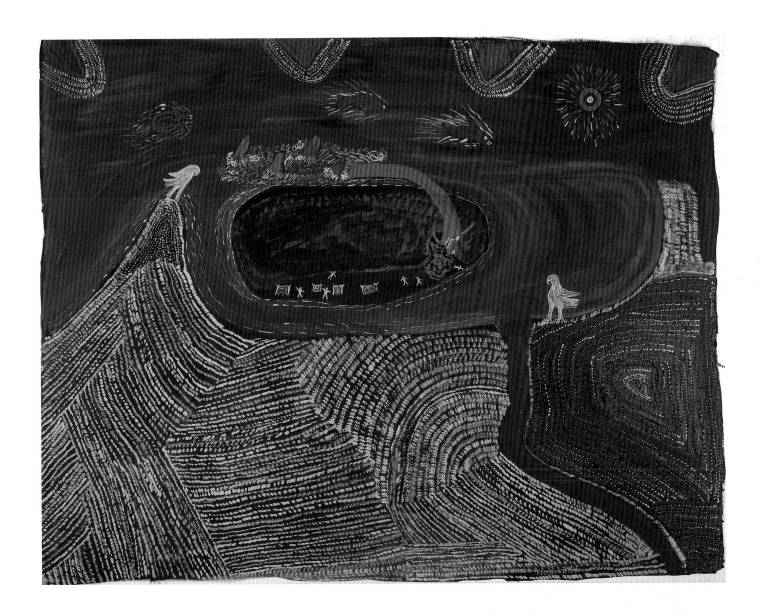

Ginger Riley Munduwalawala

Mara born *c.*1937

The Limmen Bight River

1990
synthetic polymer paint on canvas
156.0 x 202.0 cm
Ngukurr, south-east Arnhem Land,
Northern Territory

The island of Yumunkuni
(Beatrice Island) was created by
Ngak Ngak, the Sea Eagle. It lies
at the mouth of the Limmen
Bight River which flows into the
Gulf of Carpentaria. The painting
depicts an incident where a
firebreathing Rainbow Serpent
called Bulukbun came out of the
sea. Bulukbun had been offended
by the participants in a ceremony.
He emerged to devour them.

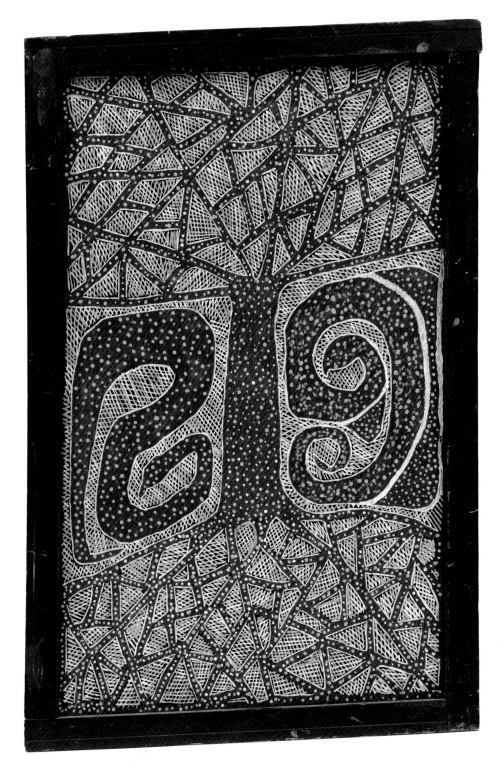

Djambu Barrabarra

Wagilag born 1937

no title

*c.*1984
synthetic polymer paint on eucalyptus bark
91.8 x 58.2; with frame 92.0 x 60.9 x 2.3 cm
Ngukurr, south-east Arnhem Land,
Northern Territory

Barrabarra is a member of the
Wagilag clan whose country
includes the site of Ngilipidji —
an important quarry of quartzite
used for making knife blades and
spearheads. These stones are traded
over a wide area of Arnhem Land.
The two curling snakes dominate
the image. The work is unusual
in its use of synthetic brightly
coloured paint on a sheet of
bark which has been framed by
the artist.

Robin Nilco

Murrinh-Amor born 1956

Water python and boomerangs

1990
synthetic polymer paint on canvas
152.5 x 45.0 cm
Wadeye (Port Keats), Northern Territory

The Water Python is the main totem
of the artist. The pythons depicted
on this canvas, whose unusual shape
recalls that of the oval bark paintings
made in the 1950s and 1960s,
point towards a central creek —
the source of life.

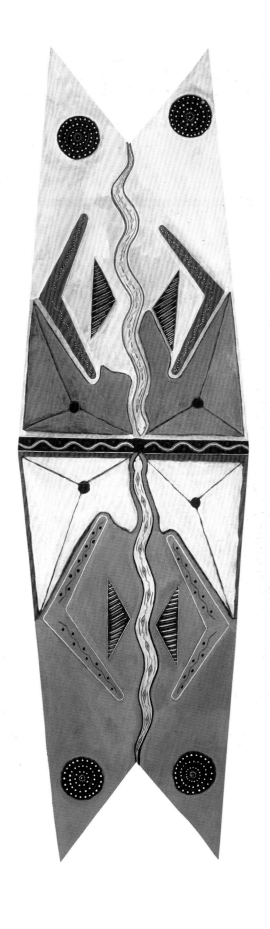

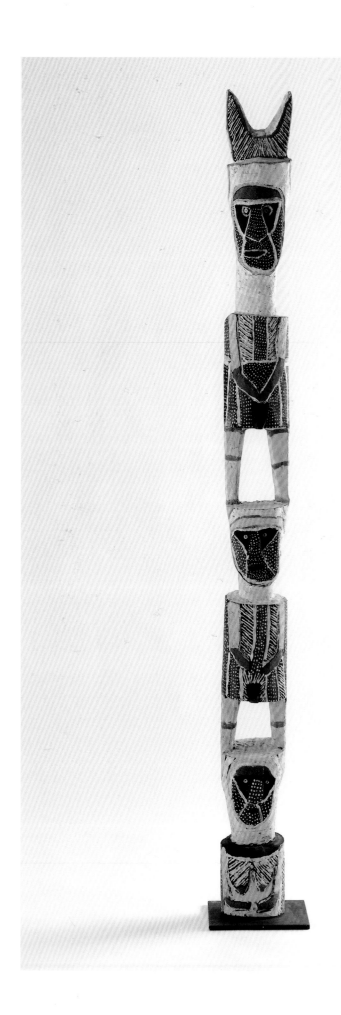

Marie Celine Porkalari
Tiwi *c.*1926–1994
Old woman/man/Lucifer
1988
ironwood, natural pigments
180.5 x 16.0 x 16.0 cm
Paru, Melville Island, Northern Territory

The Catholic mission established on
Bathurst Island in 1911 has had a
major influence on the Tiwi people.
Old woman/man/Lucifer is based on
the Pukumani pole format —
the carved and painted funeral posts
of the Tiwi — and relates the ancestral
narrative of Purukuparli and his wife
Bima within a Catholic ideology.
For example, Tapara the Moon Man
has become the devil Lucifer, complete
with horns.

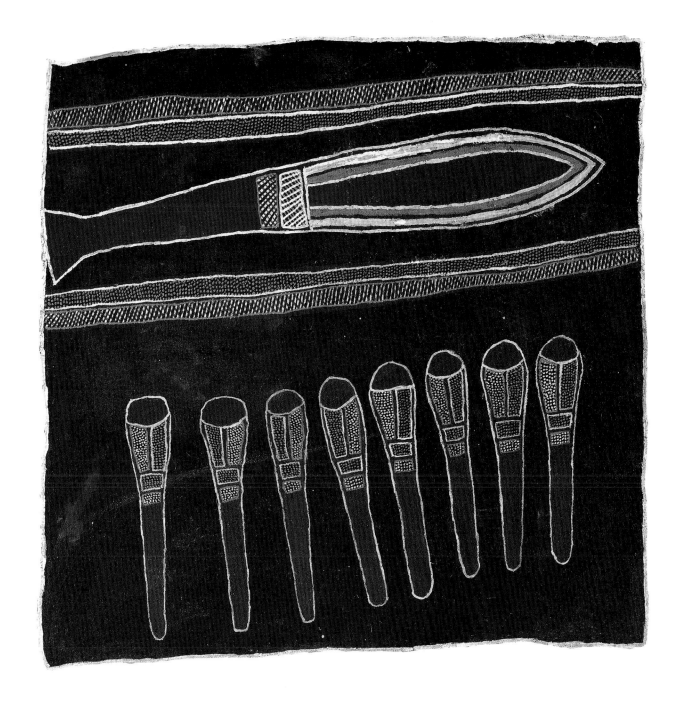

Declan Apuatimi

Tiwi 1930–1985

Clubs

*c.*1985
natural pigments on canvas
90.0 x 90.0 cm
Nguiu, Bathurst Island, Northern Territory

Declan Apuatimi was one of the most
respected, innovative and versatile
artists of the modern period.
He worked in a variety of media,
including paintings on canvas produced
in the last two years of his life.
This painting shows *murukuwunga*,
a fighting club used by the Tiwi people.

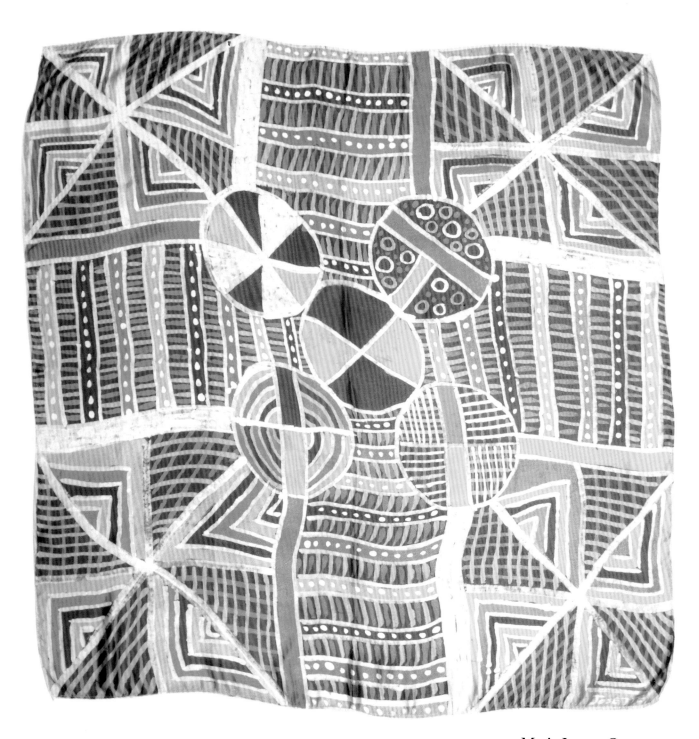

Maria Josette Orsto

Tiwi born 1962

Untitled

1989
batik on silk
110.0 x 109.7 cm
Nguiu, Bathurst Island, Northern Territory

The desire to experiment is encouraged in traditional
Tiwi culture. Younger artists especially are exploring different
print media, producing a repertoire of designs that are
uniquely Tiwi. Like her father, Declan Apuatimi,
Maria Josette Orsto is a versatile artist. This bold, geometric
design takes advantage of the flowing nature of the silk fabric.

Bede Tungutalum

Tiwi born 1952

Yam

1991
colour lithograph on paper
68.4 x 47.4 cm
Nguiu, Bathurst Island, Northern Territory
Gordon Darling Fund 1992

Bede Tungutalum was one of the
founding members of the printmaking
cooperative workshop, Tiwi Designs,
which was established in 1969.
In this print Tungutalum has
reinterpreted the traditional yam
design. The preparation of the
poisonous or 'cheeky' yam is an
important part of the annual Kurlama
ceremony of the Tiwi people.

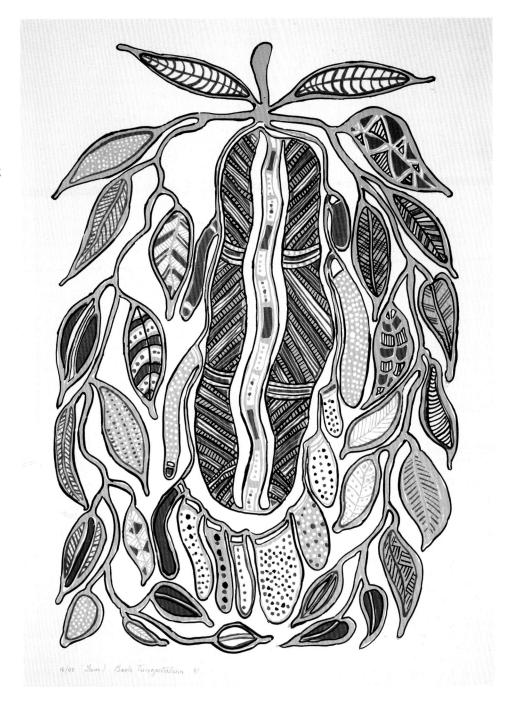

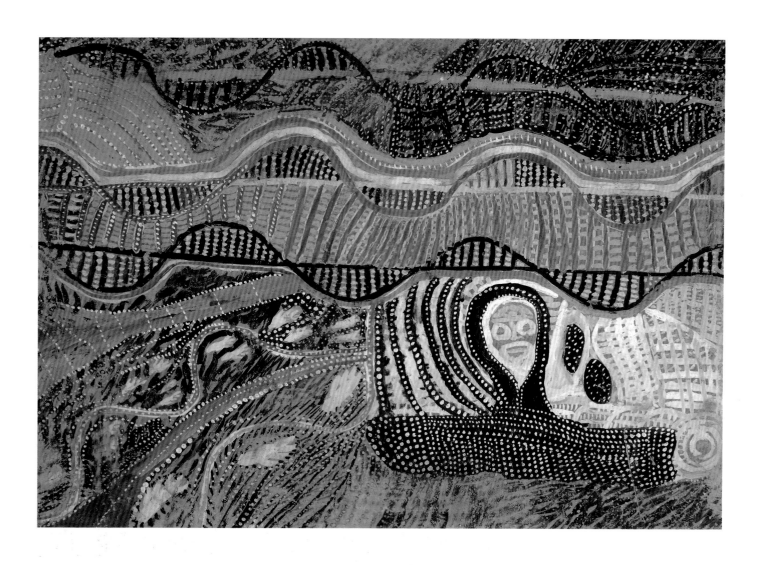

Johnny Warangkula Tjupurrula
Luritja, Warlpiri, Pintupi born 1918
Bush-fire Dreaming
1971–72
synthetic polymer paint on composition board
39.2 x 57.9 cm
Papunya, Northern Territory

An old man, Bungalung, is chased by
Wallaby spirit people. He becomes
trapped in a bush-fire and is burnt to
death. The footprints depict the old
man's futile attempt to escape the fire.
The flames are represented by the large
orange band across the centre of the
painting and the burnt landscape by
the black marks above it.

Clifford Possum Tjapaltjarri

Anmatyerre born *c.*1932
Bush-fire II
1972
synthetic polymer paint on board
61.0 x 43.0 cm
Papunya, Northern Territory

The burnt-out camp of the ancestral Possum and its tracks are shown partly obscured by ashes and charcoal. Ash is represented by light areas of colour, and burnt-out country by the darker areas that partly cover the sacred motifs. The dotting technique evident in such early paintings from Papunya has become a common feature of the work of the desert painters.

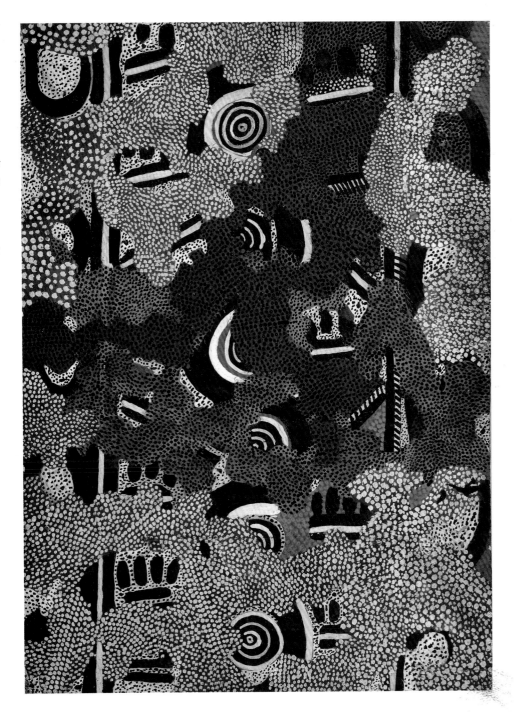

Maxie Tjampitjinpa
Warlpiri born 1945
Bush-fire
1992
synthetic polymer paint on canvas
181.5 x 91.0 cm; 181.5 x 91.0 cm; 181.0 x 91.0 cm;
182.0 x 91.2 cm
Papunya, Northern Territory

Fire is used as a means of caring for
the land by burning off the
undergrowth. Although based on
the concept of the bush-fires of
the Dreaming this work by
Maxie Tjampitjinpa emphasises
the atmospheric effects caused by
fire and smoke.

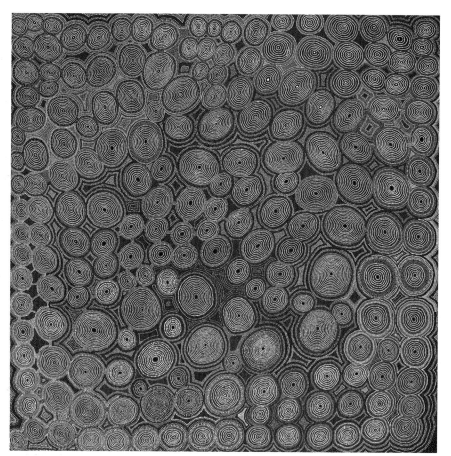

Anatjari Tjampitjinpa
Pintupi born c.1927
Ceremonial ground at Kulkuta
1981
synthetic polymer paint on canvas
182.5 x 182.0 cm
Kiwirrkura, Western Australia

Kulkuta is a major water soak and an important site for the ceremonies celebrating events connected with the ancestral Tingari beings. This painting shows the ceremonial ground where the participants sit around camps. The site is surrounded by water. The large circles represent older men who are decorating the younger ones (small circles) with Tingari designs. The minimal use of icons is characteristic of these esoteric paintings by Pintupi artists.

Abie Jangala
Warlpiri born 1919
Frog jumping,
Kamira to Kurpurluna
1989
synthetic polymer paint on canvas
180.0 x 119.0 cm
Lajamanu, Northern Territory

The Frog, Wulwarna, spends winter,
or the dry season, underground in his
home, Kamira, sleeping and waiting
for the rain. The distant rain clouds
of the wet season beckon Wulwarna
who travels towards the rain from
Kamira to Kurpurluna. The sinuous
lines indicate the flood sweeping
across the land, while the semi-circular
shapes represent the legs of the Frog.

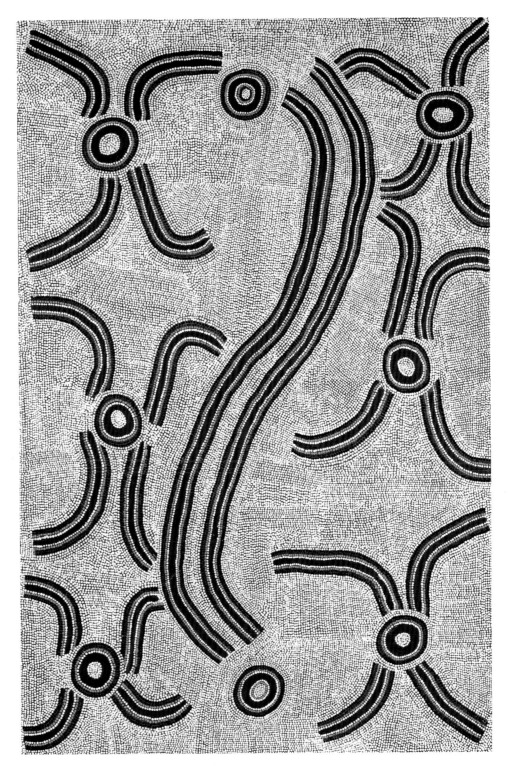

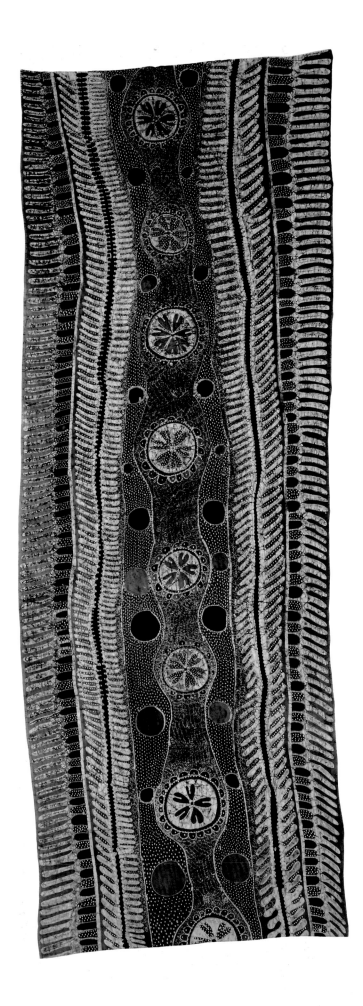

Angkuna Kulyuru
Pitjantjatjara born 1943
Untitled
1994
batik on silk
300.0 x 120.0 cm
Ernabella, South Australia

Following the introduction of batik in 1972, Ernabella artists have produced intricately patterned silks similar to traditional Javanese batiks. This elegant design by Angkuna Kulyuru shows organic forms based on leaves, flowers and plants.

Clarise Nampijinpa Poulson
Warlpiri born 1957
Yankirri Jukurrpa
(Emu Dreaming)
1992
synthetic polymer paint on canvas
182.0 x 60.5 cm
Yuendumu, Northern Territory

The Emu ancestors created the site
of Walyka, south-west of Yuendumu,
as they travelled through the area in
the Dreamtime. The tracks of emus
are shown leading to and from their
egg-filled nest. In this striking work,
Nampijinpa Poulson's vibrant use of
colour is intensified by the dots
painted within dots of colour.

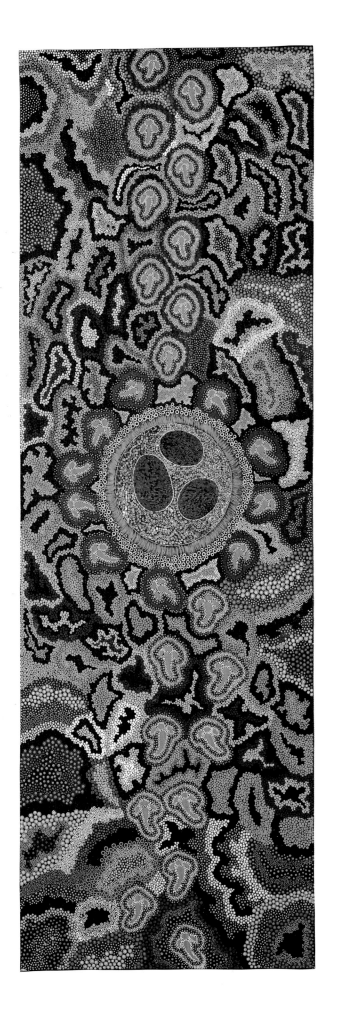

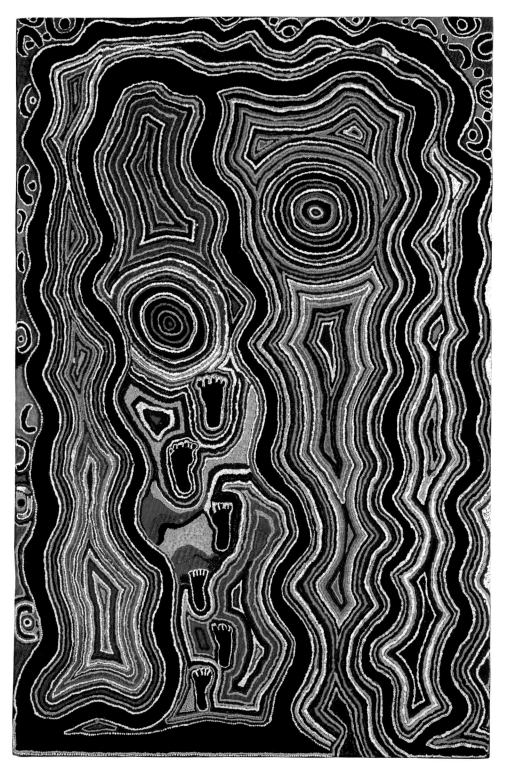

Mick Tjakamarra Gill

Kukatja born 1920

Nyuntul

1990

synthetic polymer paint on canvas

180.0 x 120.0 cm

Balgo, Western Australia

This painting tells of the Water Dreaming in the artist's country and of its many different sources. The father of the artist 'carried' the rains here on his head and left them at the claypan. His footprints can be seen in the painting. Lightning then flashed from Nyuntul rockhole, frightening the old man, who ran away and hid under a hill. He remains there today.

Ena Nungurrayi Gimme

Kukatja *c.* 1955–1991

Wantarlpa rock hole

1991
synthetic polymer paint on canvas
120.0 x 60.0 cm
Balgo, Western Australia

Ena Nungurrayi Gimme depicts her mother's country in this painting. The country has a number of unusual rock formations surrounding a waterhole. These formations were created during a big fire in the Tjukurrpa (Dreaming). The flowers and grasses in the area are shown.

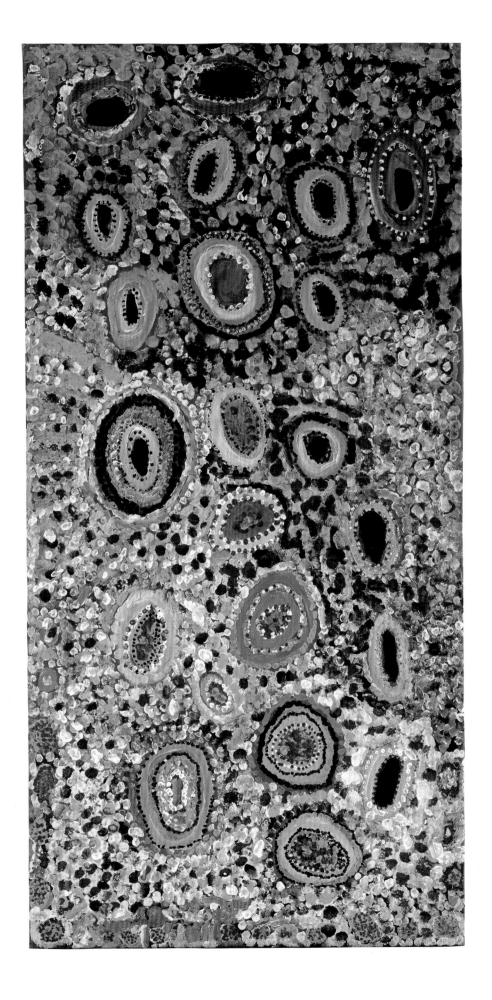

Emily Kame Kngwarreye

Anmatyerre born *c.*1916

The Alhalkere suite

1993
synthetic polymer paint on canvas
22 panels, each 90.0 x 120.0 cm
Utopia, Northern Territory

Kngwarreye's monumental work is
a response to her country, Alhalkere.
Its twenty-two panels evoke the effects
of the cycles of nature on the land,
and the spiritual forces that imbue it.

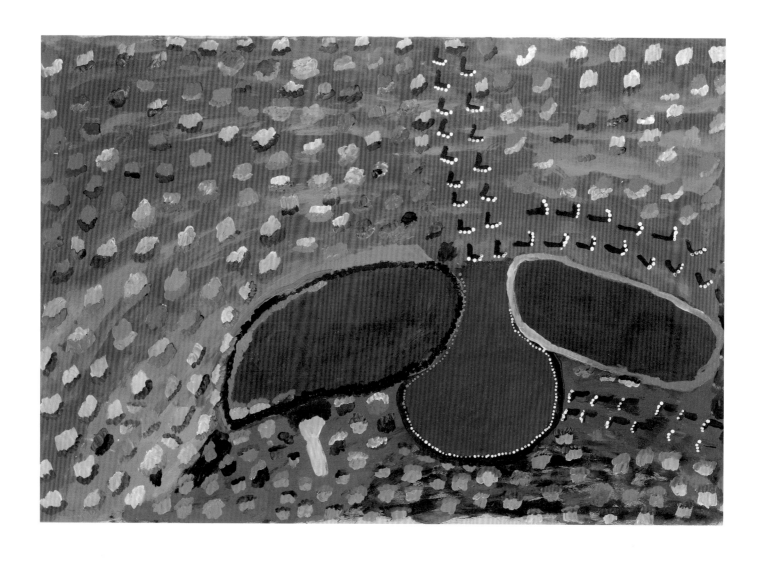

Ivy Nixon (Janyka)
Walmajarri born *c*.1935
Untitled
1992
gouache on paper
75.0 x 105.0 cm
Fitzroy Crossing, Great Sandy Desert,
Western Australia

Ivy Nixon paints her country, the area
around Louisa Downs station.
Although no narrative accompanies
this work, it shows the paths of people
leading to a waterhole.

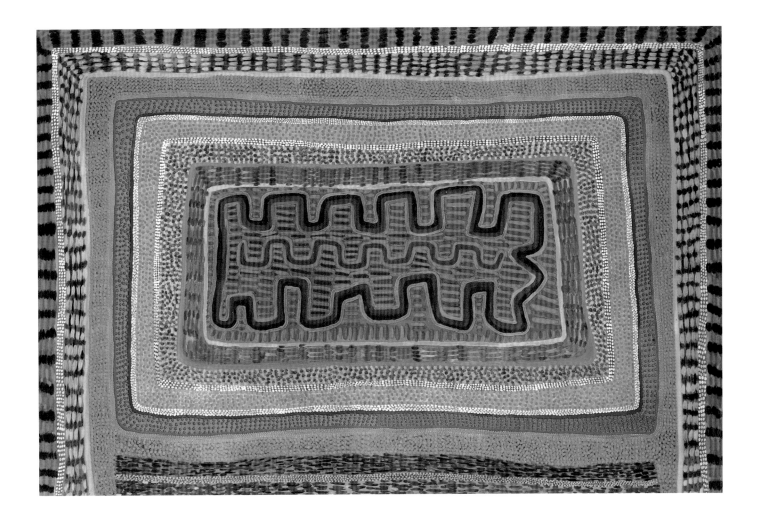

Jimmy Pike
Walmajarri born 1940
Japingka waterhole
1986
synthetic polymer paint on composition board
128.0 x 189.0 cm
Great Sandy Desert, Western Australia

The painting shows the artist's
ancestral site, where the six
Pajarriwarnti brothers were dragged
down into the waterhole and turned
into a snake. Ngalyamarra is a rock
ledge around the deep water-hole.

51

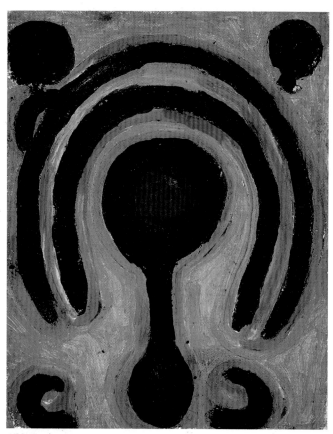

Kurtal Spring Soak with mud sculptures

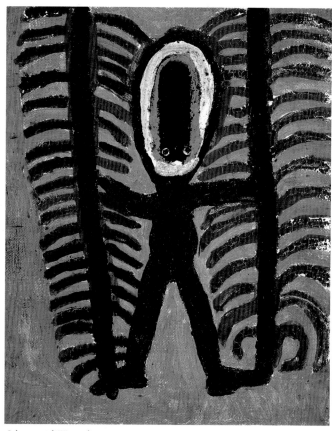

Jakarra with Witi poles at Yapurnu

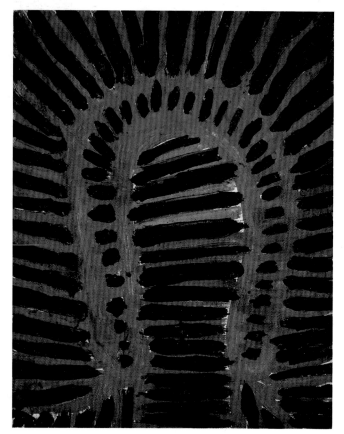

Kurtal rock-hole

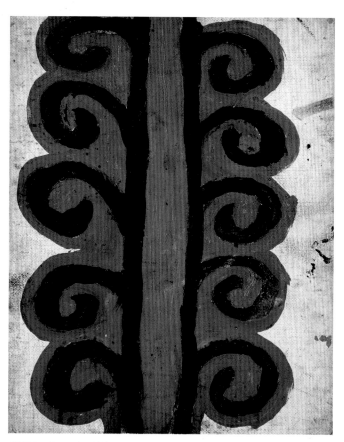

Old Man Jawanti at Muluja

Alex Mingelmanganu

Kulari, Wunambal died 1981

Wandjina

c.1980
natural pigments and oil on canvas
160.0 x 142.0 cm
Kalumburu, Western Australia

To safeguard the continuation
of the cycles of nature, it is the duty of
the Wandjina's human descendants to
preserve the rock paintings of them
which abound in the Kimberley.
Mingelmanganu continued the
tradition in his canvases which convey
the scale of the rock paintings.

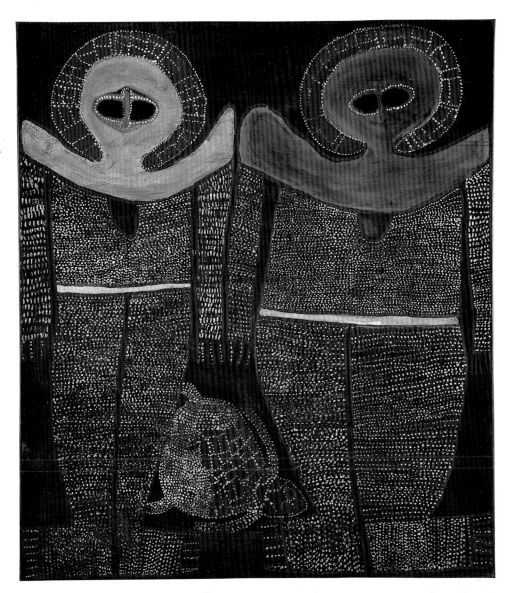

Jarinyanu David Downs

Wangkajunga, Walmajarri c.1925–1995

(a set of 4 small canvas boards)

c.1980
natural pigments and synthetic polymer paint
on canvasboard
25.2 x 20.6 cm; 25.2 x 20.2 cm;
25.2 x 20.2 cm; 25.2 x 20.1 cm
Fitzroy Crossing, Great Sandy Desert,
Western Australia

Kurtal, the ancestral leader of
Walmajarri people's ceremonies,
has the power to bring the life-giving
rains to the Great Sandy Desert.
Participants in the ceremonies are
depicted wearing headdresses and
carrying staffs. A variation on the
theme of the headdress represents
billowing rain clouds.

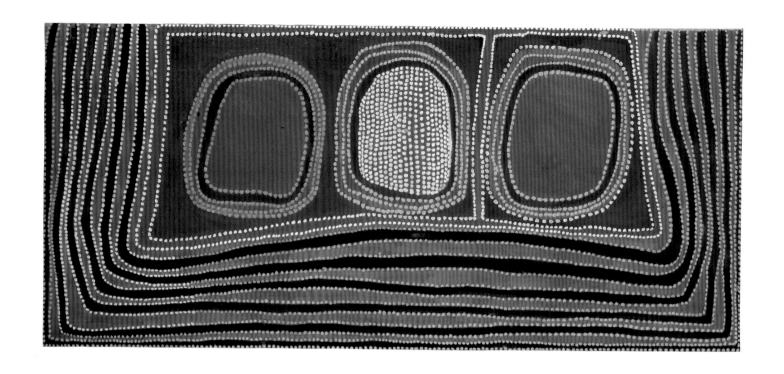

Rover Thomas
Kukatja, Wangkajunga born 1926
Barramundi Dreaming
natural pigments on canvas
90.0 x 199.7 cm
Warmun (Turkey Creek), Western Australia

The painting shows three hill tops
surrounded by their layered sides.
In the Dreaming, Lundari the Emu
drops a Barramundi fish here.
The central hill contains the scales
(white dots) of the Barramundi.
The region is now also renowned
for its diamonds.

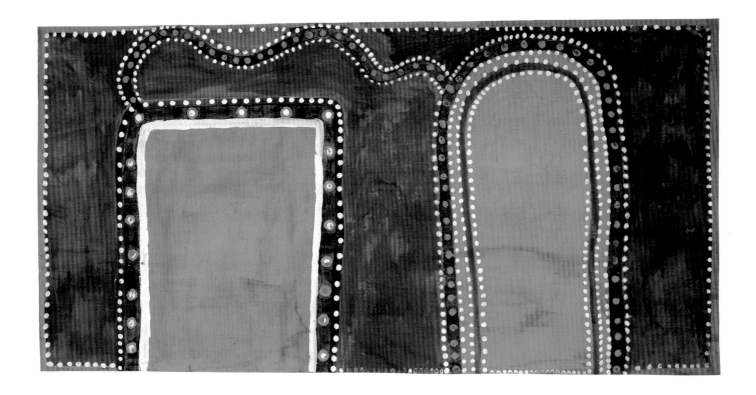

Paddy Jaminji
Kija born 1912–1996
Kurnkukurnku at Jilyili
1984
natural pigments and binders on composition board
90.0 x 180.0 cm
Warmun (Turkey Creek), Western Australia
Purchased from National Gallery
admission charges 1985

The artist creates a 'map' of the
geographic and historical topography
of the Kimberley; the ancestral track
joins a swamp to a hill.

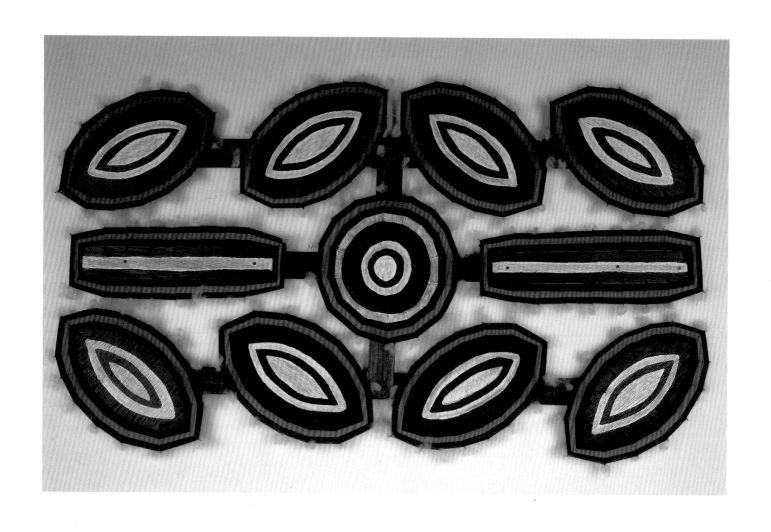

Roy Wiggan
Bardi born 1930
Ilma: Islands at King Sound
1994
synthetic polymer paint on wood,
cottonwool, nails, wool
102.0 x 58.0 cm
Broome, Western Australia

Ilma is a term used to refer to public
ceremonies performed by the Bardi
people near Broome in Western
Australia. It also describes the objects
used in the ceremonies. This ilma
shows a large whirlpool (centre circle)
surrounded by islands.

Ken Thaiday
born 1950
Whoumerr (frigate bird)
dance mask
1991
plywood, wire, rubber, fishing line,
cotton string, enamel, plastic
50.0 x 26.0 x 49.0 cm
Erub (Darnley Island), Torres Strait

Frigate birds flock to Darnley Island
in the Torres Strait when the
north-westerly winds are blowing.
This modern dance machine is used
by male dancers at feasts, weddings,
and tombstone unveilings. It is
operated by pulling both side strings
together to move the wings. The front
string when pulled forward makes
the bird dive down to catch the fish.

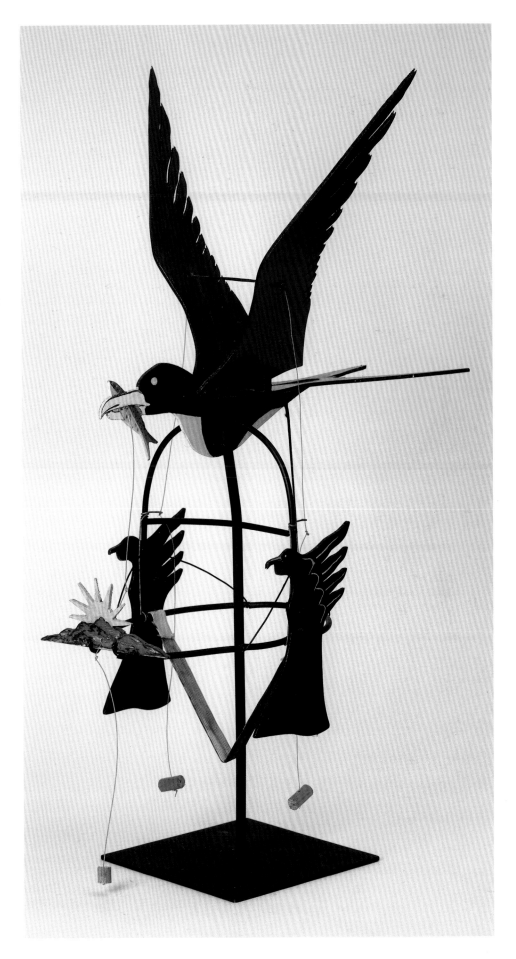

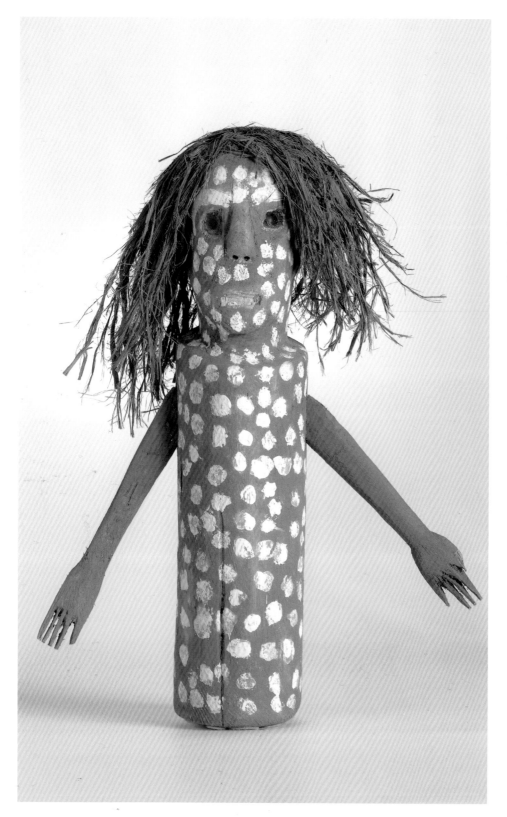

Jackson Woolla
Wik-Ngathana born 1930
Figure
1989
natural pigments on wood, fibres
49.0 x 36.0 x 12.0 cm
Aurukun, north Queensland

The sculpture is associated with the
tragic story of the two Quail women
who 'sang' to each other across the
Kirke estuary, mourning the death
of one of the sister's babies.
The dotting on the figure relates
to the shimmering of clear water after
the monsoon season in western
Cape York Peninsula.

Burrud (Lindsay Roughsey)
Lardil born *c.*1913
Rainbow Serpent
1966
natural pigments on board
80.0 x 30.0 cm
Mornington Island, north Queensland

The Rainbow Serpent symbol is of
great significance in Aboriginal
culture, as evidenced by its ubiquitous
nature in cultural practices, dance,
ceremony and painting. This intricate
design shows Thuwathu the Rainbow
Serpent as he travels through the
country to a place called Boogargun,
the place of death.

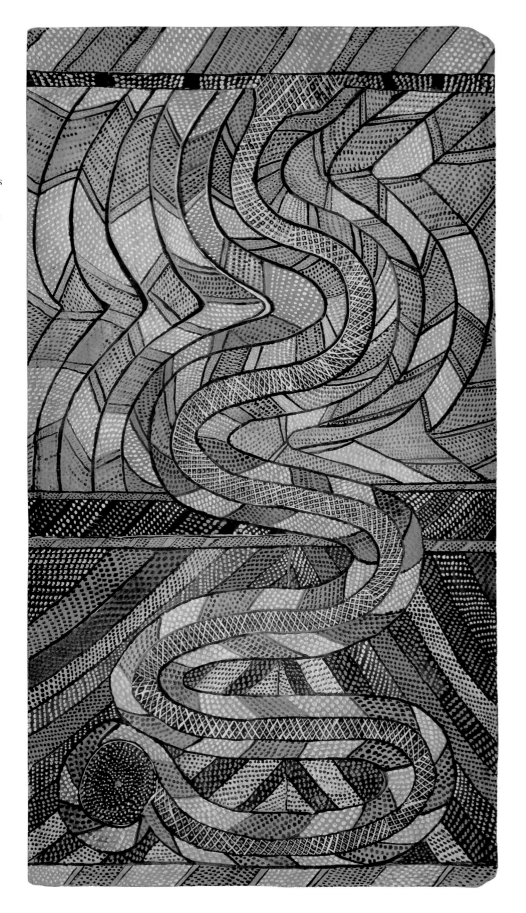

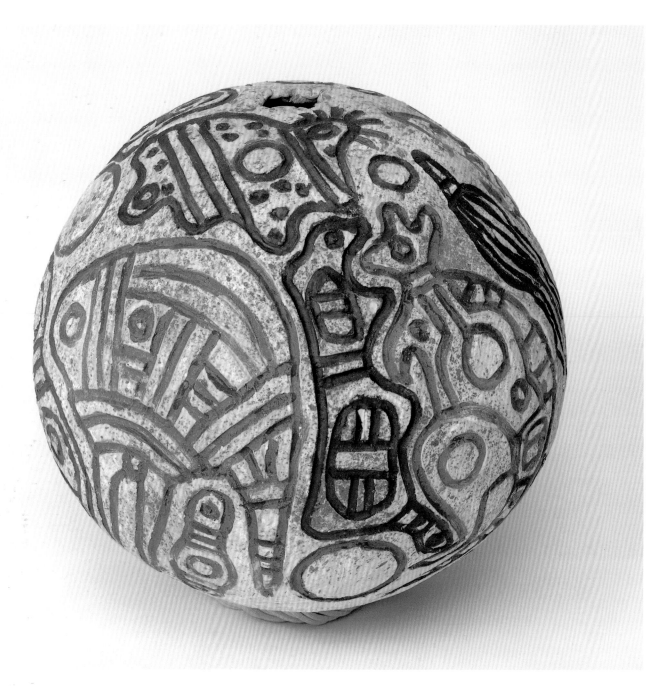

Thancoupie
Thanaquith born 1937
Moocheth, the Ibis;
Arough, the Emu;
Golpondon, the Ibis's son
1988
hand-built earthenware
27.7 x 30.7 cm (diameter)
Trinity Beach, north Queensland
Purchased from National Gallery admission charges

This vessel relates to the episode in
Thanaquith people's Dreaming where
Arough and Moocheth's relatives
and a great dancer were overcome by
the Ibis's jealous husband.

60

Arone Raymond Meeks
born 1957
Seagasm II
1981
colour lithograph on paper
49.2 x 32.0 cm
Sydney
Gordon Darling Fund 1992

The evocative sexual imagery and fluid sense of movement captured in this work continue the artist's fascination with the fertile nature of coastal seas of Australia.

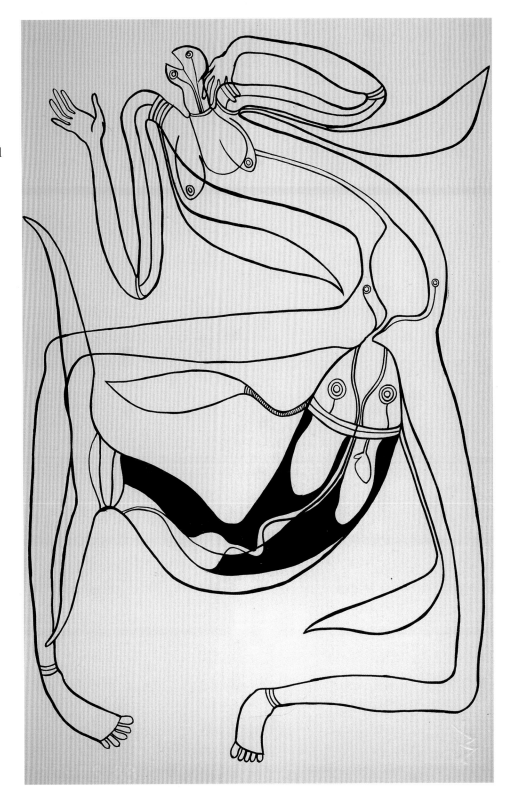

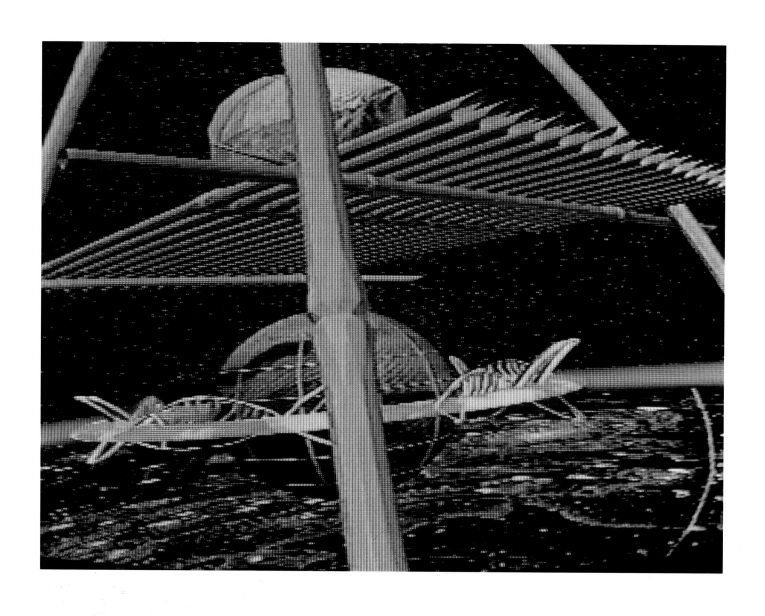

Ellen José
born 1951
In the balance
1993
still from the video *In the balance*
computer animated video; 2 min. 41 sec.
Melbourne

José's video is a celebration of
Torres Strait Island culture and history,
while at the same time serving as a
reminder of the environment's fragility.

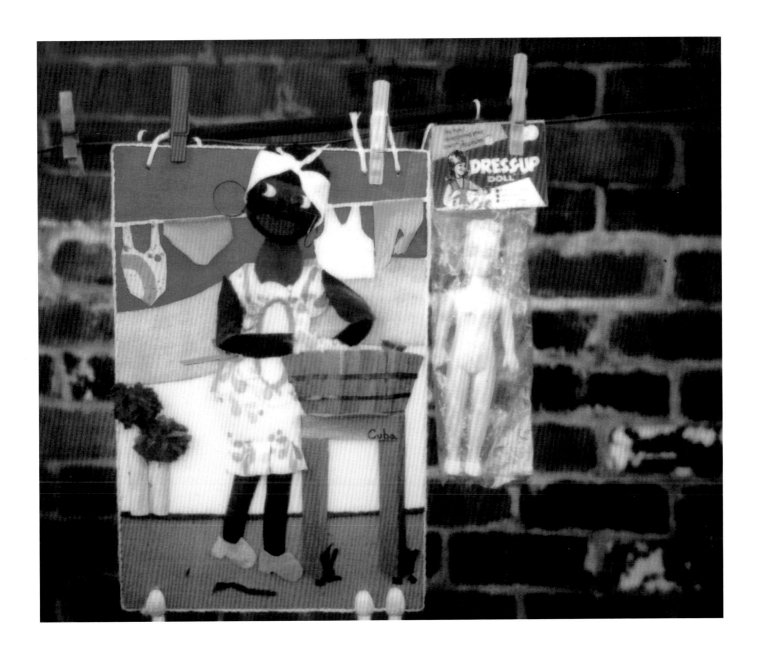

Destiny Deacon
K'ua K'ua and Erub Islands, Torres Strait born 1957
Hanging out
1994
laser photoprint off polaroid originals
58.0 x 72.0 cm
Melbourne

The artist satirically attacks the mass
production of images of racial stereotypes.

63

Brenda L. Croft
Gurindji born 1964
Millie, Norma, Sue, Leanne,
Sylvia, Jarvin, Jeremiah,
Jaden, Shanae
1993
photograph, R3 colour print
100.0 x 100.0 cm
Sydney

This is about being a black woman —
you might be a mother, sister, aunt,
cousin, daughter, friend —
no difference, the DEAL is the same.
Brenda L. Croft

Leah King-Smith
born 1957

Untitled No.3
(William Barack)
from the series
Patterns of Connection
1992
direct positive colour photograph
102.5 x 103.0 cm
Melbourne
KODAK (Australasia) Pty Ltd Fund 1994

William Barak (Barack) is one of
the few named Aboriginal artists from
the nineteenth century. The layered
image suggests the passing of time,
merging past and present narratives —
at once engaging the intellect,
the emotions and the spirit.

Michael Riley
Wiradjuri born 1960

Sacrifice,
from the series *Sacrifice*

1993
gelatin silver photographs
(left to right, top to bottom) 15.8 x 22.8 cm;
22.6 x 15.6 cm; 15.6 x 22.8 cm; 15.8 x 22.8 cm;
23.2 x 15.8 cm;15.8 x 22.8 cm;15.8 x 22.8 cm;
22.8 x 15.4 cm;15.8 x 22.8 cm
Sydney
Purcheased with the assistance of the
KODAK (Australasia) Pty Ltd Fund 1993

*In the 1940s and 1950s missionaries
tried to assimilate Aboriginal and
Islander people — they tried to control
Aboriginal lives.* [The works in this
series allude to some of the] *sacrifices
Aboriginal people made to be Christian.*
Michael Riley

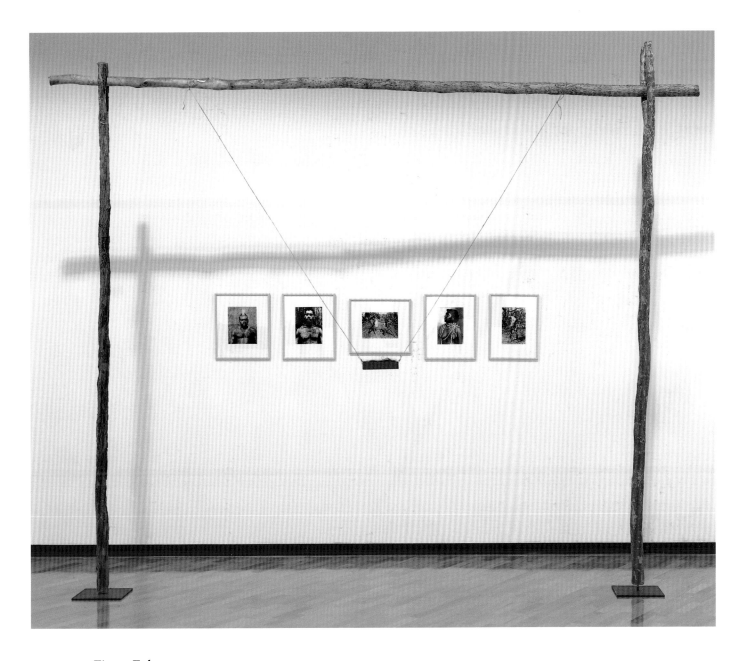

Fiona Foley

Badtjala born 1964

Lost Badtjalas, severed hair

1991
wood, string, hair, paper,
framed gelatin silver photographs
337.0 x 428.0 cm, depth variable
Maningrida, central Arnhem Land, Northern Territory,
and Sydney

Anonymous photographs originally
taken for scientific investigation early
this century have been reclaimed by
the artist — a descendant of the
subjects — and used in this work.
A sense of mourning is expressed
through the forked-stick structure
which carries a box of the artist's
own hair.

Judy Watson
born 1959
Dropping into water slowly
1993
powder pigment on canvas
225.0 x 68.5 cm
Sydney

Watson's techniques for creating landscape paintings imitate the forces of nature which form the features of the country. Rather than describing the landscape, her work evokes the land, or in this case, cascading water.

Sally Morgan
born 1951
Wittenoon (landscape II)
1991
oil on canvas
91.5 x 61.0 cm
Fremantle, Western Australia

In this painting, Morgan abandons the narrative form of much of her earlier work to express an immediate reaction to the landscape.

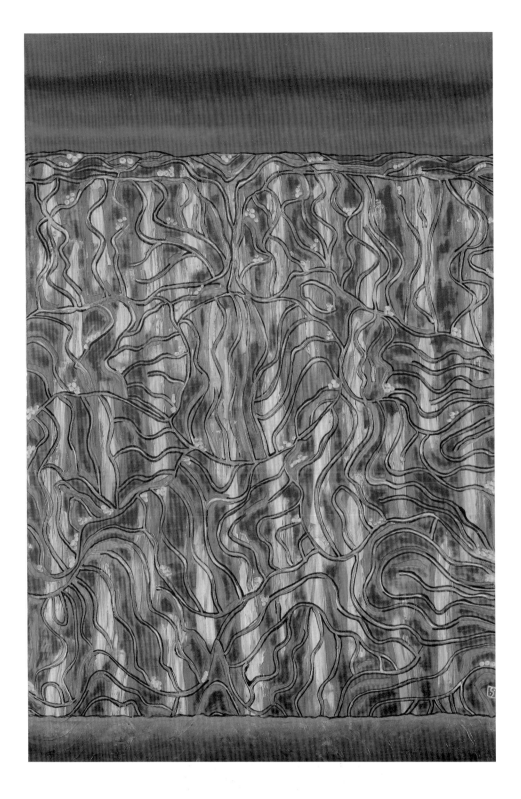

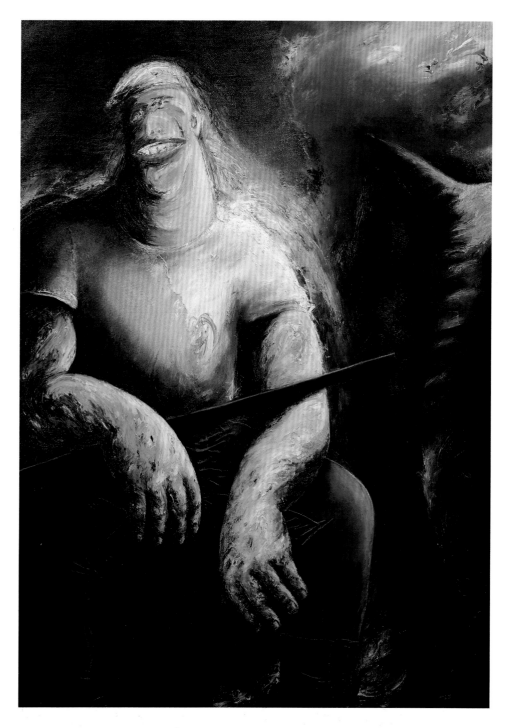

Karen Casey
born 1956
"Got the bastard"
1991
oil and mixed media on canvas
210.0 x 150.0 cm
Melbourne

The carcass of the Tasmanian tiger
(now believed extinct) hangs in the
dimly lit background of the painting
as a symbolic reference to the
treatment of the Aboriginal people of
Tasmania, hunted almost to extinction
in the 1870s. This masterful work
evokes the deliberate omission of their
story from Australian history and the
more universal issues of environmental
destruction.

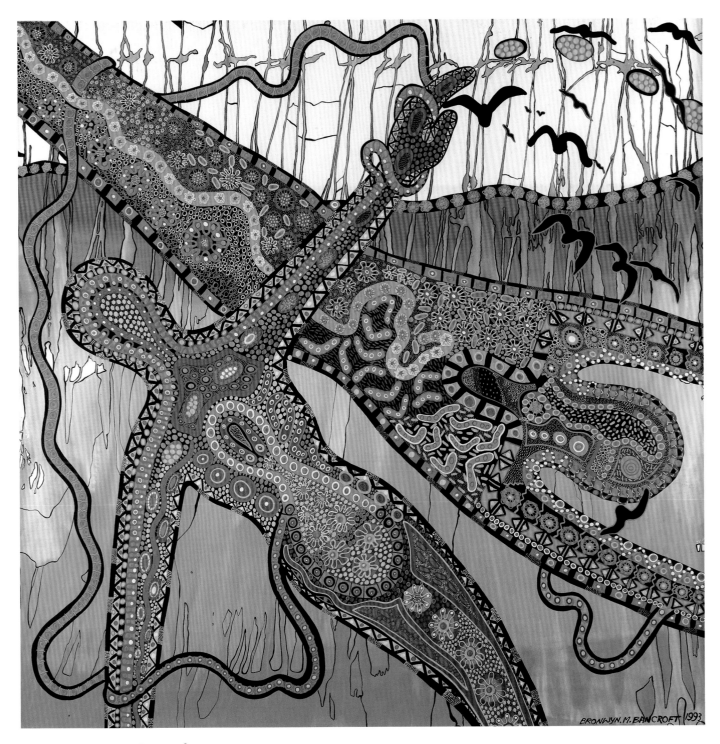

Bronwyn Bancroft
Bunjulung born 1958
My land escape
1993
gouache on paper
160.0 x 160.0 cm
Sydney

The title of this work is a play on words
referring to the European tradition of
landscape painting. The male and female
figures float over the land, their bodies
imbued with colour and symbol.

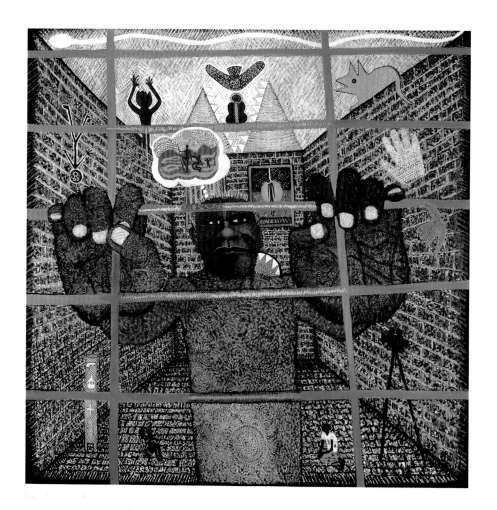

Trevor Nickolls
born 1949
Deaths in custody
1990
synthetic polymer paint on canvas
150.0 x 150.0 cm
Adelaide

For many decades the high rate of
unjust imprisonment of indigenous
Australians went unnoticed.
This powerful image of an Aboriginal
inmate with his huge hands raised,
resting on the cell bars, confronts
the viewer directly. All the elements
of the painting are contained within
the prison cell itself yet work to invade
the space of the viewer making its
subject impossible to ignore.

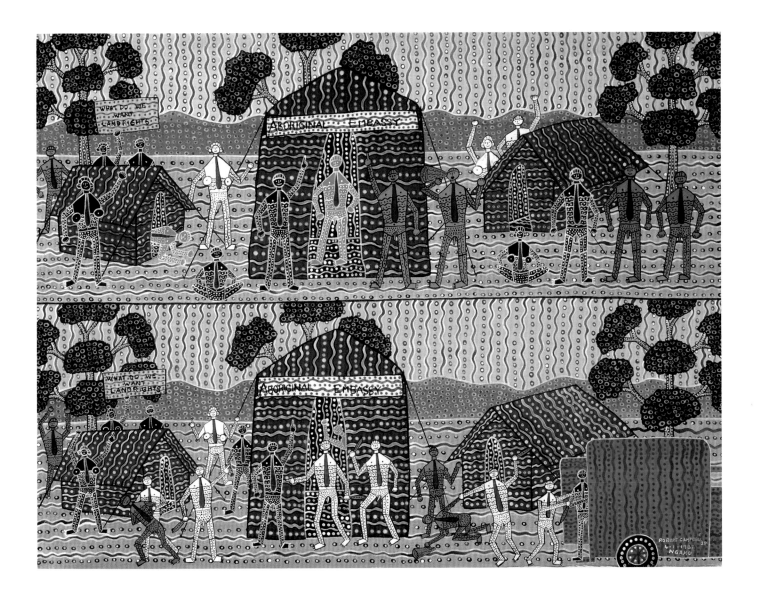

Robert Campbell Jnr
Ngaku 1944–1993
Aboriginal embassy
1986
synthetic polymer paint on canvas
88.0 x 107.3 cm
Kempsey, New South Wales

Robert Campbell records Aboriginal
(Australian) history. The red 'tie'
oesophagus symbolising the spirit is
depicted on all living beings in the
painting. The Aboriginal tent embassy,
originally established outside
Parliament House in Canberra,
was a landmark in Australia's move to
the recognition of indigenous land
rights. The embassy was re-established
on the twentieth anniversary of the
original tent embassy.

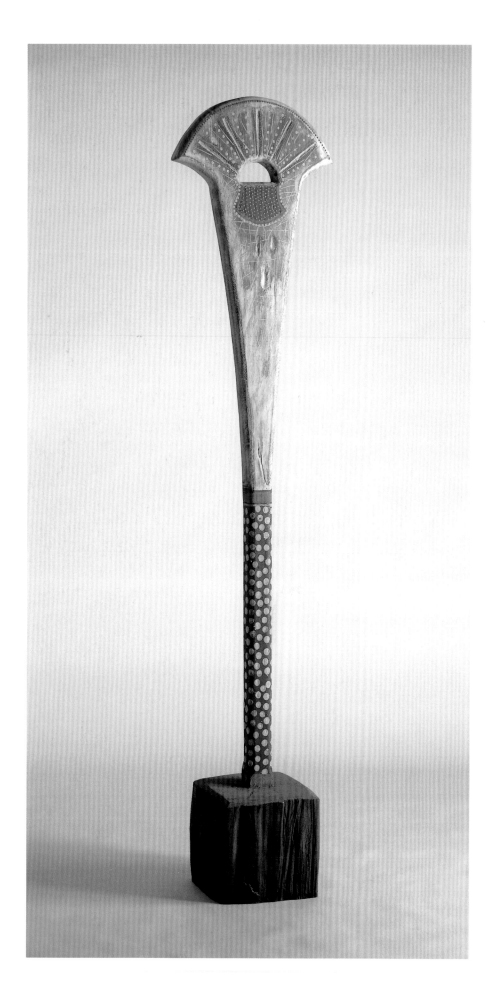

David Jangalinji
born *c.*1931
*Dreaming before youth
and after old age*
1991
natural pigments and synthetic polymer paint on wood
200.0 x 44.0 x 28.0 cm
Brewarrina, New South Wales

Jangalinji's sculpture recalls artefacts
produced in eastern Australia in
the nineteenth century. The delicate
colours and incised marks contrast
sharply with the rough-hewn quality
of the carved and shaped wood.
The work concerns notions of eternity,
the cycles of nature and the Dreaming.

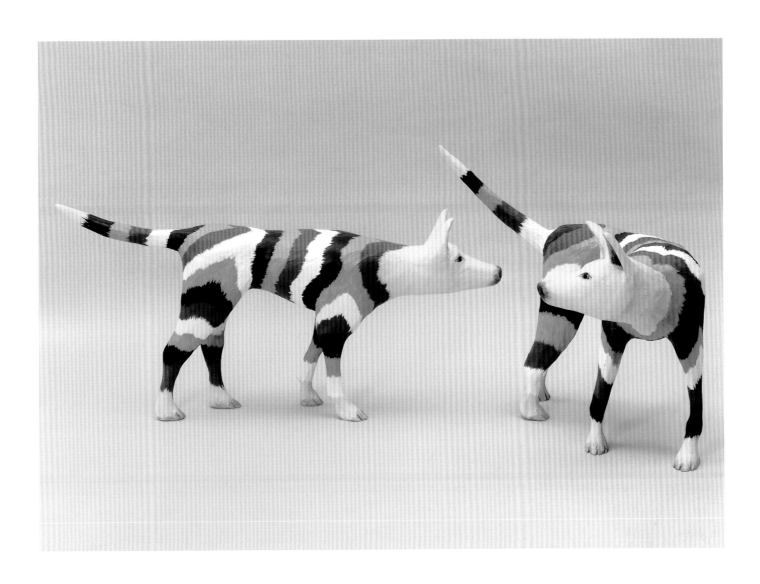

Lin Onus

Yorta Yorta born 1948

Anal fetish

from the series *Dingoes*

1989
synthetic polymer paint on fibreglass, wire, metal
71.0 x 74.0 x 50.0 and 57.0 x 121.0 x 20.0 cm
Melbourne

These sculptures are part of a series
concerning the native dog. Through
a sense of humour and empathy the
works challenge perceptions of fear
and distaste about this often maligned
Australian animal.

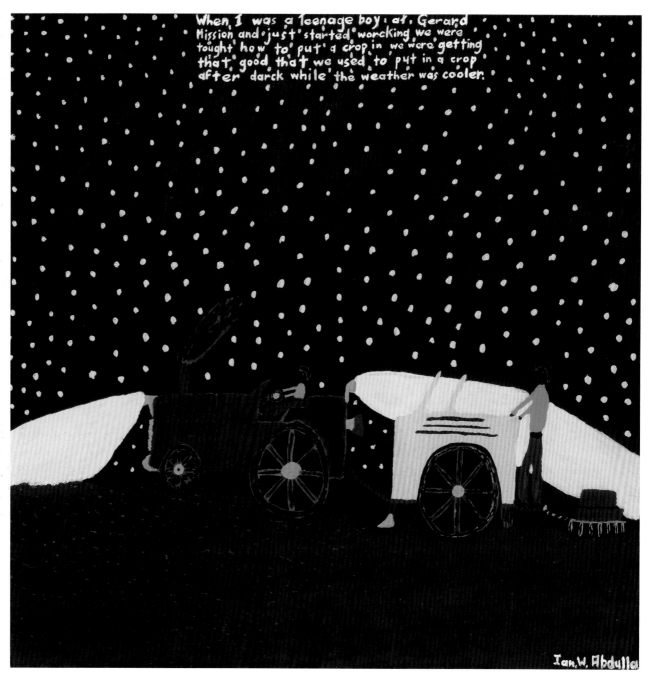

When I was a teenage boy at Gerard Mission and just started worcking we were tought how to put a crop in we were getting that good that we used to put in a crop after darck while the weather was cooler.

Ian. W. Abdulla

Ian W. Abdulla
Ngarrindjeri born 1947
Sowing seeds at nite
1990
synthetic polymer paint on canvas
100 x 100 cm
Adelaide, South Australia
Moet and Chandon Fund 1991

Ian W. Abdulla's work records a period in rural Aboriginal histories referred to as the Depression of the 1950s, when Aboriginal families such as Abdulla's sought an independent life away from the mission. These personal life experiences provide the subject matter for the artist.

Liz McNiven

Budjiti born 1963

Spirit Dreaming

1993
neon light
124.0 x 124.0 x 13.0 cm
Canberra

This design symbolises Aboriginal
Dreaming. The spiral centre to the
design is one of the oldest art designs
in the world.

*The spiral is used to represent the
continuation of our spirituality —
our Dreaming — our Nations.*

Liz McNiven

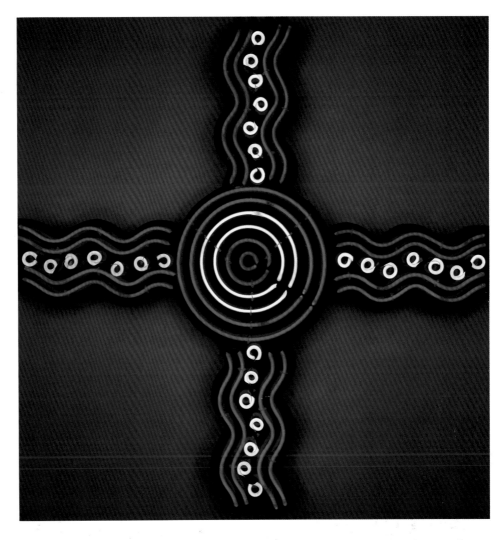

Selected further reading

Aboriginal Arts Board 1979, *Oenpelli Bark Paintings*, Ure Smith, Sydney.

Amadio, N. & Kimber, R.G. 1987, *Wildbird Dreaming: Aboriginal Art from the Central Deserts of Australia*, Greenhouse Publications, Melbourne.

Bardon, G. 1979, *Aboriginal Art of the Western Desert*, Rigby, Adelaide.

Bardon, G. 1991, *Papunya Tula: Art of the Western Desert*, McPhee Gribble, Melbourne.

Beier, U. 1985, *Dream Time — Machine Time: The Art of Trevor Nickolls*, Robert Brown & Associates and the Aboriginal Artists Agency, Sydney.

Beier, U. & Johnson, C. 1988, *Long Water: Aboriginal Art and Literature Annual*, Aboriginal Artists Agency, Sydney.

Berndt, R.M. (ed.) 1964, *Australian Aboriginal Art*, Ure Smith, Sydney.

Berndt, R.M. 1974, *The Australian Aboriginal Heritage: An Introduction through the Arts*, Ure Smith, Sydney.

Berndt, R.M., Berndt, C.H. with Stanton, J.E. 1982, *Aboriginal Australian Art: A Visual Perspective*, Methuen Australia, Sydney.

Boulter, M. 1991, *The Art of Utopia: A New Direction in Contemporary Aboriginal Art*, Craftsman House, Sydney.

Brandl, E.J. 1973, *Australian Aboriginal Paintings in Western and Central Arnhem Land*, Australian Institute of Aboriginal Studies, Canberra.

Brody, A.M. 1985, *The Face of the Centre: Papunya Tula Paintings, 1971–1984* (exhibition catalogue), National Gallery of Victoria, Melbourne.

Brody, A.M. 1990, *Contemporary Aboriginal Art: The Robert Holmes à Court Collection* (exhibition catalogue), Heytesbury Holdings, Perth.

Caruana, W. 1987, *Australian Aboriginal Art: A Souvenir Book of Aboriginal Art in the Australian National Gallery*, National Gallery of Australia, Canberra.

Caruana, W. (ed.) 1989, *Windows on the Dreaming: Aboriginal Paintings in the Australian National Gallery*, National Gallery of Australia, Canberra, and Ellsyd Press, Sydney.

Caruana, W. 1993, *Aboriginal Art*, World of Art Series, Thames and Hudson, London and New York.

Cooke, P. & Altman, J. (eds) 1982, *Aboriginal Art at the Top* (exhibition catalogue), Maningrida Arts and Crafts, Maningrida, Northern Territory.

Coombs, H.C., McCann, H., Ross, H. & Williams, N.M. 1989, *Land of Promises: Aborigines and Development in the East Kimberley*, Centre for Resource and Environmental Studies, Australian National University, Canberra.

Cooper, C., Morphy, H., Mulvaney, J. & Peterson, N. 1981, *Aboriginal Australia* (exhibition catalogue), Australian Gallery Directors Council Ltd, Sydney.

Crawford, I.M. 1968, *The Art of the Wandjina: Aboriginal Cave Paintings in the Kimberley, Western Australia*, Oxford University Press, Melbourne.

Crocker, A. (ed.) 1981, *Mr Sandman Bring Me a Dream*, Papunya Tula Artists, Alice Springs, and Aboriginal Artists Agency, Sydney.

Croft, B.L. 1993, *The Big Deal is Black* (exhibition catalogue), Boomalli Aboriginal Artists Co-operative, Sydney.

Croft, B. & Perkins, H. 1994, *True Colours: Aboriginal and Torres Strait Islander Artists Raise the Flag*, Boomalli Aboriginal Artists Co-operative, Sydney

Crumlin, R. 1991, *Aboriginal Art and Spirituality*, Collins Dove, A Division of Harper Collins Publishers, Melbourne.

Dewdney, A. & Phillips, S. 1994, *Racism, Representation & Photography*, Inner City Education Centre, Sydney.

Eather, M & Hall, M. 1990, *Balance: Views, Visions, Influences* (exhibition catalogue), Queensland Art Gallery, Brisbane.

Edwards, R. (ed.) 1978, *Aboriginal Art in Australia*, Ure Smith, Sydney.

Edwards, R. & Guerin, B. 1969, *Aboriginal Bark Paintings*, Rigby, Adelaide.

Gunn, G. 1973, *Groote Eylandt Art: Leonhard Adam Ethnological Collection — Part One* (exhibition catalogue), University of Melbourne, Melbourne.

Isaacs, J. 1982, *Thancoupie the Potter*, Aboriginal Artists Agency, Sydney.

Isaacs, J. 1984, *Australia's Living Heritage: Arts of the Dreaming*, Lansdowne Press, Sydney.

Isaacs, J. 1989, *Aboriginality: Contemporary Aboriginal Paintings and Prints*, University of Queensland Press, Brisbane.

Johnson, T. & Johnson, V. 1984, *Koori Art '84* (exhibition catalogue), Artspace, Sydney.

Johnson, V. 1987, *Art & Aboriginality 1987* (exhibition catalogue), Aspex Gallery, Portsmouth, United Kingdom.

Johnson, V. 1994, *Aboriginal Artists of the Western Desert: A Biographical Dictionary*, Craftsman House, Sydney.

Johnson, V. 1994, *The Art of Clifford Possum Tjapaltjarri*, Gordon and Breach, Sydney.

Johnson, V. 1990, *The Painted Dream: Contemporary Aboriginal Paintings from the Tim and Vivien Johnson Collection* (exhibition catalogue), Auckland City Art Gallery, Auckland, New Zealand.

Kupka, K. 1965, *Dawn of Art: Paintings and Sculptures of Australian Aborigines*, Angus & Robertson, Sydney.

Kupka, K. 1972, *Peintres Aborigines d'Australie*, Musée de l'Homme, Paris.

Lowe, P. with Pike, J. 1990, *Jilji: Life in the Great Sandy Desert*, Magabala Books, Broome, Western Australia.

Luthi, B. (ed.) 1993, *Aratjara: Australian Aboriginal Art* (exhibition catalogue), Kunstsammlung Nordrhein-Westfalen, Düsseldorf, and DuMont Verlag, Cologne, Germany.

Mangkaja Arts Resource Agency 1991, *Karrayili: An Exhibition of Works by Students of Karrayili Adult Education Centre, Fitzroy Crossing and Bayulu Community, Kimberley, Western Australia* (exhibition catalogue), Tandanya, National Aboriginal Cultural Institute Inc., Adelaide.

Maughan, J. & Zimmer, J. (eds) 1986, *Dot and Circle: A Retrospective Survey of the Aboriginal Acrylic Paintings of Central Australia* (exhibition catalogue), Royal Melbourne Institute of Technology, Melbourne.

Milpurrurru, G. with Caruana, W., Getjpulu, G., Mundine, D. & Reser, J. 1993, *The Art of George Milpurrurru* (exhibition catalogue), National Gallery of Australia, Canberra.

Moore, D.R. 1989, *Arts and Crafts of Torres Strait*, Shire Ethnography, Aylesbury, United Kingdom.

Morphy, H. 1991, *Ancestral Connections*, The University of Chicago Press, Chicago and London.

Mountford, C.P. 1956, *Art, Myth and Symbolism of Arnhem Land*, Records of the American–Australian Scientific Expedition to Arnhem Land, vol. 1, Melbourne University Press, Melbourne.

Mountford, C.P. 1958, *The Tiwi: Their Art, Myth and Ceremony*, Phoenix House, London.

Mundine, D. 1992, *Paintings and Sculptures from Ramingining by Jimmy Wululu and Philip Gudthaykudthay* (exhibition catalogue), Australian National University Drill Hall Gallery, Canberra.

Mundine, D. with Foley, F. 1992, *Tyerabarrbowaryaou: I Shall Never Become a White Man* (exhibition catalogue), Museum of Contemporary Art, Sydney.

Mundine, D. with Foley, F. 1994, *Tyerabarrbowaryaou: I Shall Never Become a White Man II* (exhibition catalogue for the Havana Biennale, Cuba), Museum of Contemporary Art, Sydney.

O'Ferrall, M.A. 1989, *On the Edge: Five Contemporary Aboriginal Artists* (exhibition catalogue), Art Gallery of Western Australia, Perth.

O'Ferrall, M.A. 1990, *1990 Venice Biennale. Australia: Rover Thomas — Trevor Nickolls*, Art Gallery of Western Australia, Perth.

O'Ferrall, M.A. 1990, *Keepers of the Secrets: Aboriginal Art from Arnhem Land*, Art Gallery of Western Australia, Perth.

Parbury, N. 1988, *Survival: A History of Aboriginal Life in New South Wales*, Ministry of Aboriginal Affairs (NSW), Sydney.

Perkins, H. 1991, *Aboriginal Women's Exhibition* (exhibition catalogue), Art Gallery of New South Wales, Sydney.

Ryan, J. 1989, *Mythscapes: Aboriginal Art of the Desert* (exhibition catalogue), National Gallery of Victoria, Melbourne.

Ryan, J. 1990, *Spirit in Land: Bark Paintings from Arnhem Land* (exhibition catalogue), National Gallery of Victoria, Melbourne.

Ryan, J. (ed.) 1993, *Aboriginal Art of the Kimberley* (exhibition catalogue), National Gallery of Victoria, Melbourne.

Stanton, J.E. 1989, *Painting the Country: Contemporary Aboriginal Art from the Kimberley Region, Western Australia*, The University of Western Australia Press, Perth.

Sutton, P. (ed.) 1988, *Dreamings: The Art of Aboriginal Australia*, Viking Press, New York.

Thomas, R., with Akerman, K., Caruana, W,. Christensen, W. & Macha, M. 1994, *Roads Cross: The Paintings of Rover Thomas* (exhibition catalogue), National Gallery of Australia, Canberra.

Thompson, L. 1990, *Aboriginal Voices: Contemporary Aboriginal Artists, Writers and Performers*, Simon & Schuster, Australia.

Ucko, P.J. (ed.) 1977, *Form in Indigenous Art*, Australian Institute of Aboriginal Studies, Canberra.

Wallace, D., Desmond, M. & Caruana, W. 1991, *Flash Pictures by Aboriginal and Torres Strait Islander Artists* (exhibition catalogue), National Gallery of Australia, Canberra.

Warlukurlangu Artists 1987, *Yuendumu Doors: Kuruwarri*, Australian Institute of Aboriginal and Torres Strait Islander Studies, Canberra.

West, M.K.C. 1987, *Declan: A Tiwi Artist* (exhibition catalogue), Australian City Properties, Perth.

West, M.K.C. (ed.) 1988, *The Inspired Dream* (exhibition catalogue), Queensland Art Gallery, Brisbane.

West, M.K.C. 1995, *Rainbow Sugarbag and Moon: Two Artists of the Stone Country — Bardayal Nadjamerrek and Mick Kubarkku* (exhibition catalogue), Museum & Art Gallery of the Northern Territory, Darwin.

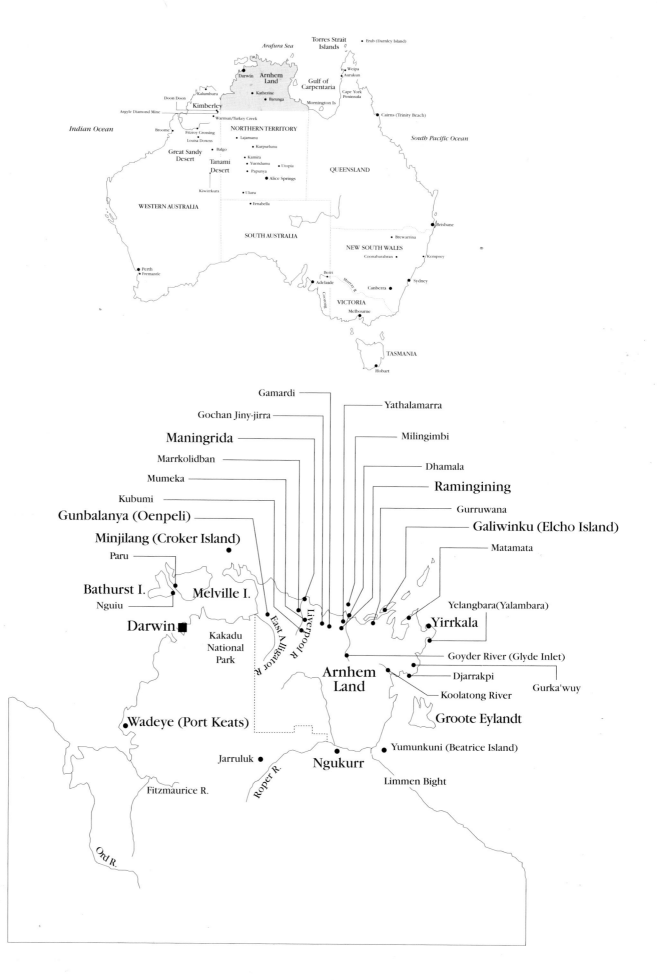

Torres Strait
Islands

Arafura Sea
Erub (Darnley Island)

Darwin Arnhem
Land Gulf of
Carpentaria Weipa
Aurukun

Kalumburu Katherine
Doon Doon Barunga Mornington Is
Kimberley Cape York
Peninsula
Argyle Diamond Mine Warmun/Turkey Creek
Cairns (Trinity Beach)

Indian Ocean Broome Fitzroy Crossing
Louisa Downs NORTHERN TERRITORY South Pacific Ocean
Balgo Lajamanu
Great Sandy Kurpurlunu
Desert Tanami Kamira QUEENSLAND
Desert Yuendumu Utopia
Papunya
Kiwirrkura Alice Springs

WESTERN AUSTRALIA Uluru
Ernabella Brisbane

SOUTH AUSTRALIA Brewarrina
NEW SOUTH WALES
Coonabarabran Kempsey

Berri Sydney
Adelaide Canberra
Perth VICTORIA
Fremantle Melbourne

TASMANIA

Hobart

Gamardi
Yathalamarra
Gochan Jiny-jirra
Milingimbi
Maningrida
Dhamala
Marrkolidban
Ramingining
Mumeka
Gurruwana
Kubumi
Galiwinku (Elcho Island)
Gunbalanya (Oenpeli)
Matamata
Minjilang (Croker Island)
Paru
Yelangbara(Yalambara)
Bathurst I. **Melville I.** **Yirrkala**
Nguiu
Goyder River (Glyde Inlet)
Darwin Kakadu
National Djarrakpi
Park Gurka'wuy
Arnhem Koolatong River
Land
Groote Eylandt
Wadeye (Port Keats)
Yumunkuni (Beatrice Island)
Jarruluk
Ngukurr
Fitzmaurice R. Limmen Bight
Roper R.

Ord R.

80